AFGHANISTAN

LADAKH

Srinagar

JAMMU AND
KASHMIR

CHI

W9-BYJ-278

Wagah
HIMACHAL
PRADESH

Amritsar

PAKISTAN

Simla

PUNJAB CHANDIGARH

Chandigarh

Rishikesh

Haridwar

UTTARANCHAL

Brahmaputra

ARUNACHAL
PRADESH

HARYANA

DELHI

Rampur

NEPAL

SIKKIM

BHUTAN

Itanagar

ASSAM

NAGALAND

New Delhi

Shahpura

RAJASTHAN

Jaipur

Agra

UTTAR PRADESH

Dispur

Kohima

Ranthambore

Tonk

Gwalior

Lucknow

Ganges

Darjeeling

BIHAR

Shillong

MEGHALAYA

MANIPUR

Rohet
Nimaj

Chambal

Sonagir

BANGLADESH

Desuri

Narlai

Deogarh

Ajadpura
Orchha

Khajuraho

Patna

Ganges

TRIPURA

MIZORAM

Udaipur

Varanasi

JHARKHAND

Bhuj

Rann of Kutch

Gandhinagar

MADHYA PRADESH

Sanchi

WEST
BENGAL

Ranchi

Calcutta

MYANMAR
(BURMA)

*Gulf
of Kutch*

Mandvi

GUJARAT

Bhopal

Bandhavgarh

Indore

Narmada

Sundarbans

Maheshwar

CHHATTISGARH

Mouth of the Ganges

INDIA

Raipur

Mahanadi

DAMAN AND DIU

MAHARASHTRA

ORISSA

Bhubaneshwar

DADRA AND
NAGAR HAVELI

Mumbai

Godavari

Bay of Bengal

Arabian Sea

Hyderabad

Krishna

INDIAN OCEAN

KARNATAKA

Benaulim

GOA

ANDHRA
PRADESH

*Andaman
Sea*

Bangalore

Kanchipuram

Bannur

Madras (Chennai)

ANDAMAN
AND NICOBAR
ISLANDS

Mysore

0 62 124 186 miles

0 100 200 300 km

TAMIL
NADU

Pondicherry

KERALA

Kumbakonam

Trichy

Tanjore

Karaikuoi

Cochin

Madurai

Alleppey

Ambalapuzha

Kumarakom Vazhoor

Thiruvananthapuram

Pulinkudi

*Gulf
of Mannar*

SRI
LANKA

The white dots in this map represent approximate
sites where *India Exposed* photographs were taken,
as well as major cities and state capitols. Map not to scale.

INDIA EXPOSED

INDIA EXPOSED

The Subcontinent A–Z

Text and photographs by Clive Limpkin

Abbeville Press Publishers

NEW YORK · LONDON

LINDENHURST MEMORIAL LIBRARY
LINDENHURST, NEW YORK 11757

Editor: Erin Dress
Production manager: Louise Kurtz
Production editor: Briana Green
Designer: Maxim Zhukov

Text and photographs copyright © 2008 Clive Limpkin.
Compilation, including selection of text and images,
copyright © 2008 Abbeville Press. All rights reserved
under international copyright conventions. No part of
this book may be reproduced or utilized in any form
or by any means, electronic or mechanical, including
photocopying, recording, or by any information
retrieval system, without permission in writing
from the publisher. Inquiries should be addressed
to Abbeville Press, 137 Varick Street, New York, NY
10013. The text of this book was set in Icone and
Meridien. Printed and bound in China.

ISBN 978-0-7892-0994-8
First edition
10 9 8 7 6 5 4 3 2 1
Library of Congress Cataloging-in-Publication Data
Limpkin, Clive, 1937–
 India exposed: the subcontinent A–Z /
 by Clive Limpkin.—1st ed.
 p. cm.
 Includes index.
 ISBN 978-0-7892-0994-8 (alk. paper)
 1. India—Pictorial works. 2. India—Description
 and travel. I. Title.
DS414.2.L56 2008
954.003—dc22 2008024813

To learn more about or to contact Clive Limpkin,
please visit his Web site, www.clivelimpkin.com.

For bulk and premium sales and for text adoption
procedures, write to Customer Service Manager,
Abbeville Press, 137 Varick Street, New York, NY 10013,
or call 1-800-ARTBOOK.

Visit Abbeville Press online at www.abbeville.com.

CONTENTS

INTRODUCTION

"India—love it or loathe it."

This slogan may never supersede the Indian Ministry of Tourism's snappy "Incredible India" campaign, but it might give a truer picture. For first-time visitors it's a gamble whether this overloaded, overpopulated, overcooked, overlooked, anarchistic madhouse will have you vowing never to go near again, or booking the next trip—no matter the cost.

Consider my wife and I in 2005, asked to join a party to surprise a friend for his birthday in Mumbai.

"Mumbai, India?" we asked. "Yes," they said. "It'll be an adventure."

The portents were not good.

I was a photojournalist retired after forty years covering much of the world for Fleet Street newspapers. The highlight of my career came in 1972 when my book *The Battle of Bogside*, depicting three years of fighting in Northern Ireland, won the Robert Capa Gold Medal from *Life* magazine "for superlative photography requiring exceptional courage and enterprise abroad." In my world, it just didn't get better than that—that was all the adventure I needed.

I'd never been to India, but Fleet Street had shown me enough airports, delays, and general travel chaos to last a lifetime; now I was being told that all the poverty, garbage, and begging I'd read about was going to be an adventure?

And here was my wife Alex, an interior designer big on minimalism, cleanliness, and hygiene, constantly battling clutter, chaos, and substandard hotel showerheads, actually wanting to go.

Anticipating disaster, I checked the bottom-line costs for heading home early. Would we get cancellation refunds from hotels? No. What about the unused internal flights? Forget it. Maybe travel insurance would help? Are you kidding?

"It's a gamble we can't afford," I decided. But Alex won, and off we went.

Arriving in darkness, we were driven to a bungalow on a spice island farm in Kerala, where we immediately crashed and fell asleep.

When I woke, Alex was standing by the open window. Music wafted in on the cool morning breeze. "Is that a radio?" I asked. "No, it's the village across the river—they're playing music, and the women are singing as the fishermen set sail."

Fearing we'd stumbled on the set of a Bollywood musical, I looked out as a white-throated kingfisher stared from ten feet away. Three mussel fishermen were drifting off to Lake Vembanad in dugouts with sails sewn together from flour sacks. They crossed paths with another boat bearing two departing guests through the flowering water hyacinth, and they stirred a flock of egrets into flight.

"It's magic," said Alex.

"But what about the showerhead?"

She shrugged. "I can live with that."

"D'you think the kingfisher will wait till I've put the 600 mm lens on?"

"What do you think?" she said.

Within twelve hours of landing, we were hooked.

In the next three years we crisscrossed the sub-

continent, seeing the best and enough of the worst, each time returning home to be cross-examined by friends who wanted to know what India was *really* like.

That's easy—it's a paradoxical, untenable, unjust, disparate, chaotic mishmash of languages, religions, philosophies, tribes, classes, castes, and people that somehow works. And all those nasty stories you've heard are true.

Poverty? You've seen nothing like it in the cities—but India is 90 percent rural, and rural poverty is a different-looking animal.

Infrastructure? Road, rail, airports, you name it, are truly chaotic—the only example of punctual efficiency comes in the presentation of your bill.

Bureaucracy? In triplicate—India is the last refuge of carbon-paper salesmen. With such a labor pool, half of Indians devote their time to making rules, the other half to breaking them. It's a triumph of the individual over the system. At Bagdogra Airport's security gate, someone took the time to hand-paint the name of every person exempt from body frisking, ranging from the president, at No. 1, to the Dalai Lama, who scrapes in at No. 21.

Begging? Yup, but for every beggar there are a million other Indians who ask only for a smile or a wave of greeting.

Garbage? By the truckload—the very scale of trash in urban India is breathtaking. (Maybe the wrong adjective.)

Hygiene? Brace yourself—local hygiene practices are strangely at odds with the Hindu culture of personal cleanliness.

When friends ask for one good reason to visit, I offer them a billion—it's the people. Whether because of the Hindu belief in karma or due to acceptance of caste lot, nowhere else do you get so many disarming smiles or waves in warm greeting. These salutations come not from those seeking your tourist dollar but from millions upon millions with nothing to their name who act like they've just won life's lottery and want you to share it.

And maybe they have. Each visit to India brings a small but perceptive change to personal ambitions and Western material priorities, downgrading the urgency of another raise, a bigger car, or a facelift. India is the real world—and most of the time, it smiles at you.

Matching this enveloping welcome is a scale of serendipity that I've met nowhere else in the world. The jaw-dropping frequency of unbelievable sights and experiences makes you laugh out loud or burns your conscience. For each one of the 80,000 shots I took, there was another I missed in that split second of disbelief, gone before I could raise my camera.

If all you want to see on vacation is your tœs at the end of a chaise lounge, then stick to Florida, but if the real world beckons, the unbelievable real world, then I hope this book might encourage you to consider India—love it or loathe it.

Clive Limpkin, January 2009

INDIA EXPOSED

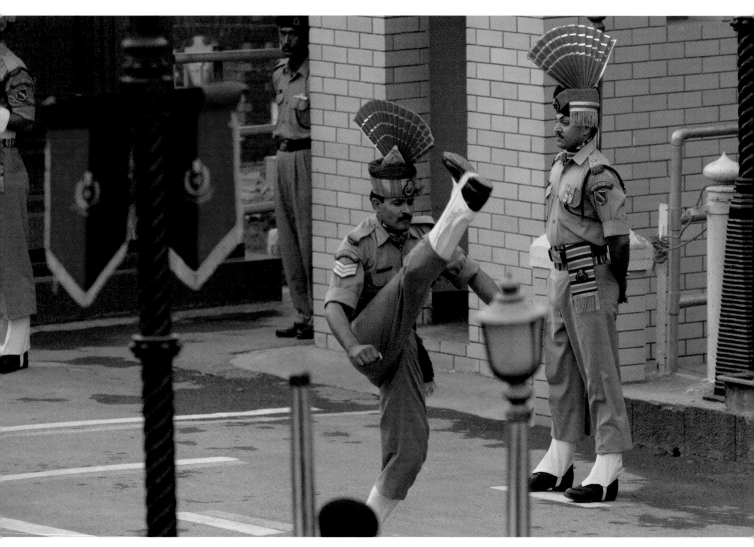

High-kicking border troops from the Indian Army during the nightly
Retreat Ceremony on the Pakistan border. Wagah, Punjab.

ARMY

Each day at dusk, the Retreat Ceremony is performed by soldiers from India and Pakistan on the border at Wagah, the only road link between the two countries. National flags are lowered as swaggering, high-kicking soldiers perform an elaborate choreography—think the Rockettes meet John Cleese—to satisfy the baying crowds who pack the grandstands on either side.

This ceremony is hardly representative of the full Indian Army, the second largest in the world with 1.3 million troops. India does not need to rely on the draft, since army life, with its regular food and wages, appeals to the poor. Manpower on this scale proved essential during the India-Pakistan Wars of 1947–48 and 1965, when the flashpoint was the disputed Kashmir territory, and again in 1971, during the Bangladesh Liberation war.

Hindu-Muslim conflict remains the main cause of India's military troubles. Though tensions remain high, at Wagah they are released nightly with pure theater that is free and not to be missed. ∎

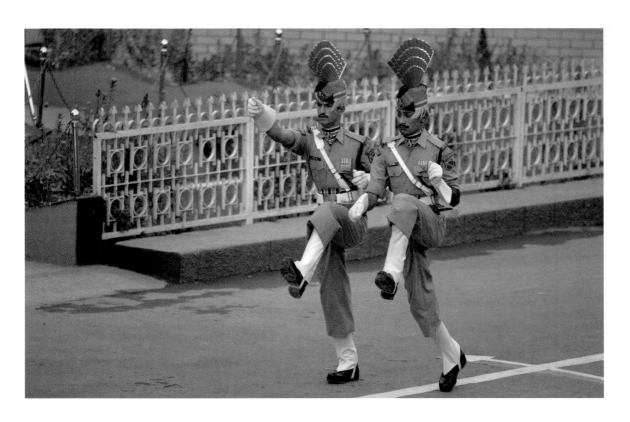

ASTROLOGY

Astrology governs the lives of most Indians, dictating their every action. From the farmer seeking the proper time to sow his seed to the government setting election dates, many Indians use astrology to distinguish the auspicious from the inauspicious. With over a dozen TV channels devoted to twenty-four-hour astrology, Indian television reflects the country's fascination with the subject.

When Bollywood star and former Miss World Aishwarya Rai announced her engagement to fellow heartthrob Abhishek Bachchan, it was described as a wedding made in heaven. However, that was before astrologers revealed Rai as a *manglik*, born when Mars is in the first, fourth, seventh, eighth or twelfth house of the Vedic astrology lunar chart. The *manglik*, according to astrologers, is bound to bring severe negatives to a relationship—anything from high tension to an early death after the union.

Had the groom also been a *manglik*, then the two negatives would have cancelled each other. Since this was not the case, however, it was decided Aishwarya Rai must perform the *kumbh vivah* ceremony, in which she first marries a banana tree. The couple subsequently married and was later quoted as being "blissfully happy." No word yet from the two-timed banana tree. ∎

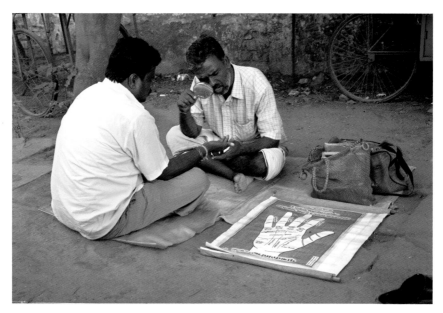

A passerby has his hand read by a street palmist who has yet to master the rudiments of the magnifying glass. Tanjore, Tamil Nadu.

AUTO-RICKSHAW

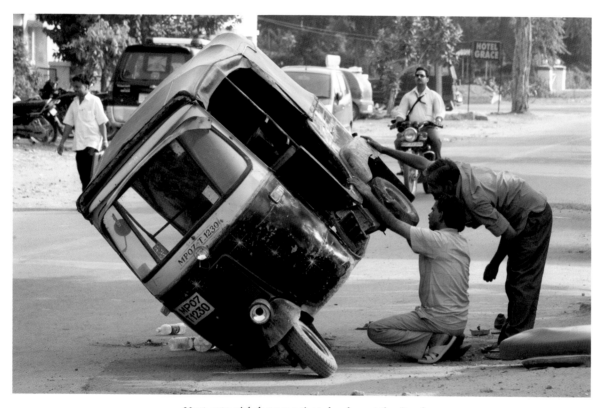

*Most auto-rickshaw repairs take place at the site of
the breakdown. Gwalior, Madhya Pradesh.*

The auto-rickshaw is a tricycle scooter with handle-bar controls and a planet-warming two-stroke engine. Whether it is actually the quickest and cheapest form of transport through India's clogged cities, as some claim, depends on the heavy-duty haggling required at the end of each journey, which might halve the fare or double the journey time, depending on how the negotiations go.

Officially the rear seats accommodate two adult passengers; unofficially, however, they might hold classrooms of children, assorted goats, sheep, market produce, furniture, and freight.

The auto-rickshaw is not for the fainthearted, as its maneuverability encourages drivers to indulge in lethal weaving. ∎

BARBERS

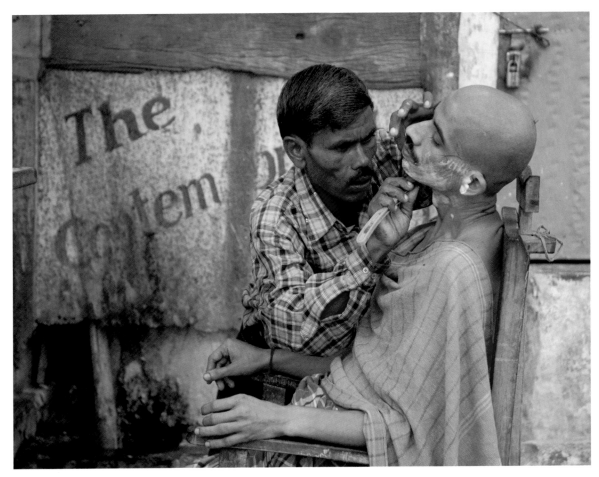

*A pilgrim has his head shaved prior to immersion in the
sacred Ganges River. Varanasi, Uttar Pradesh.*

The ubiquitous village barber has simple start-up needs: a wooden chair, brush, soap, mirror, a straight razor, and a steady hand. When business booms, after word of his expertise spreads, a barber might find enough lumber for a crude wooden hut or even invest in a proper barber's chair. ∎

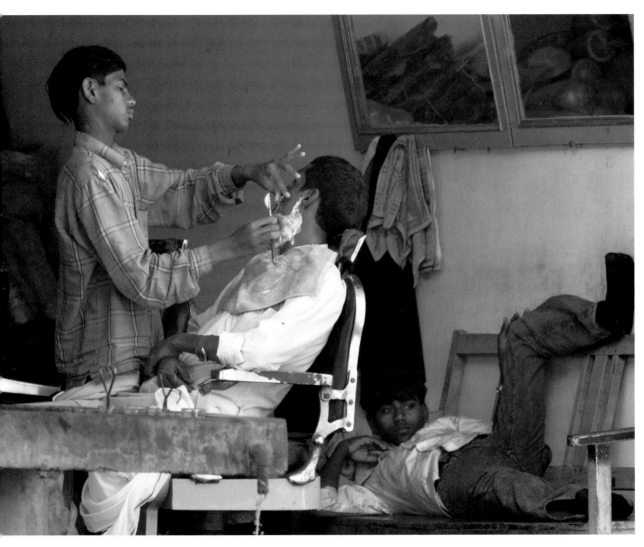

B

Such is the finesse of this young barber, he has rendered his business partner redundant. The Tonk/Jaipur road, Rajasthan.

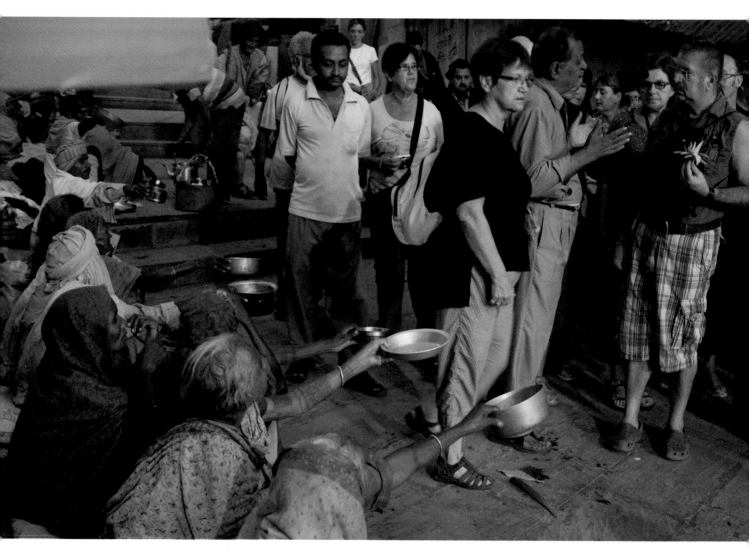

*A group of tourists are greeted with a line of
begging bowls. Varanasi, Uttar Pradesh.*

BEGGING

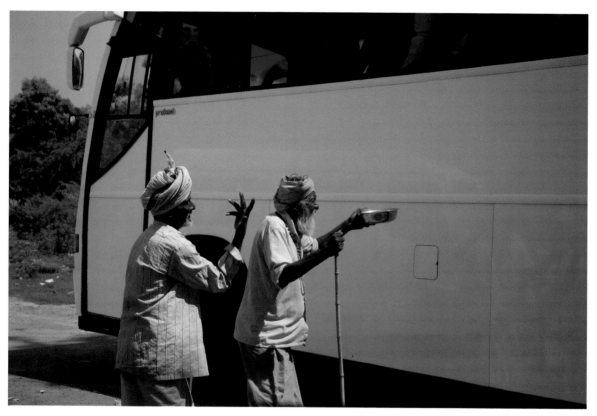

The doors close on the air-conditioned coach, sealing in departing
tourists, but the Temple's resident beggars optimistically follow it to the gates.
Brihadisvara Temple Complex, Gangaikondacholapuram, Tamil Nadu.

While India's ubiquitous beggars are often genuinely in dire need, begging is also viewed as a profession, presenting a continuous dilemma for visitors who cannot know whether their change encourages a professional or provides a lifeline to a desperate soul.

The predicament is eased for Hindus, who believe that giving to any beggar will increase their *punya*, or air miles, to heaven. The sad truth is that any donation will either encourage a professional begger or indirectly delay any government attempts at improved social care for the deserving. ∎

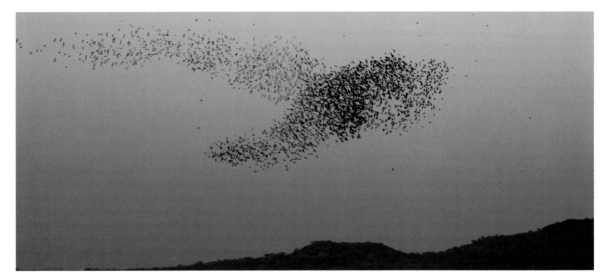

Migrating birds form an avian pattern over a village on the coast of the Arabian Sea. Birding readers with good eyesight might recognize the species. Mandvi, Gujarat.

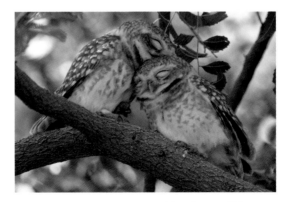

Spotted owlets are engaged in what could be foreplay—but as both sexes look very similar, they might just be good friends. Nimaj, Rajasthan.

BIRDS

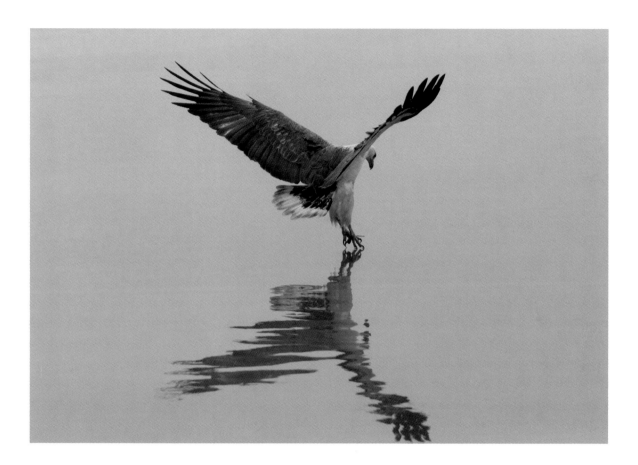

We were drawn to the Sundarbans mangrove forests at the mouth of the Ganges for the man-eating Royal Bengal tiger. But after cruising an area larger than Delaware for a few days, we were left on the last day with only a shot of a muddy paw print and a distant view of the no-go core area where the majority of tigers live. We called it a day and were in sight of camp when a white-bellied sea eagle banked above our boat and dove down to snatch a fish barely twenty yards away. The bird's mix of majestic beauty and raw power left everyone in awe.

But that's India. There are occasions when you feel that Indian birds, emboldened by the sweeping Wildlife Protection Act of 1972, will do everything but smile at the camera. Sundarbans, West Bengal.

BRICK MAKING

This is the tail end of the booming brick-making industry that feeds the booming construction industry that rides the booming economy.

Though 100 billion bricks are needed every year, this family team molds them just two at a time in the traditional way. With a thousand bricks earning just over $5, each member of such a gang earns only subsistence wages. Still, this kind of labor lures many rural peasants away from failing farms. ∎

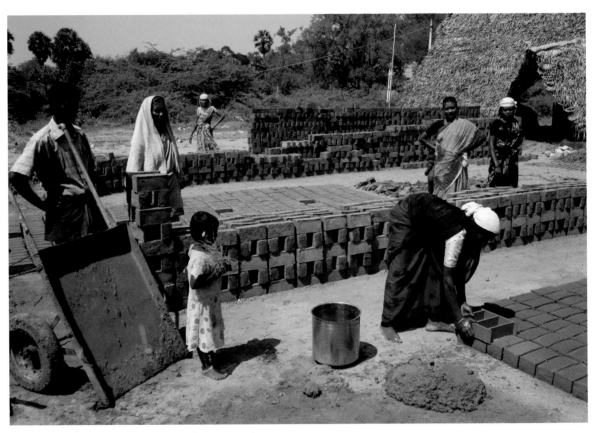

Leading a nomadic life, brick makers work wherever the clay mud can be found.
Often thumbprinting a contract they cannot read, duped by unscrupulous contractors,
they are the very tip of the tail of the tiger economy. Madurai, Tamil Nadu.

BUFFALO

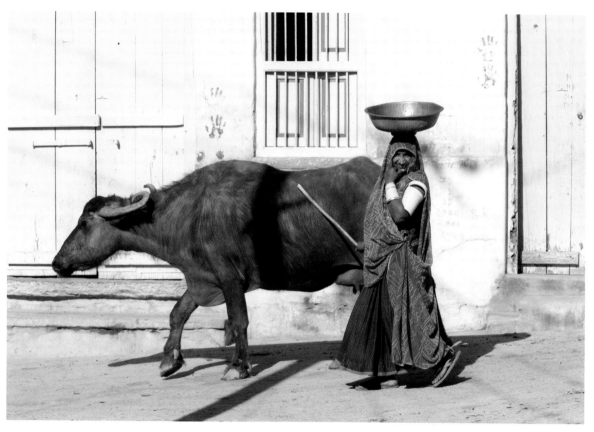

A coy villager leads a buffalo, keeping her bowl handy for the prized manure.
(The handprints on the wall are to bring good luck, as is everything else in India
that doesn't appear to have an immediate purpose.) Narlai, Rajasthan.

Powered only by cheap grazing or fodder, the domesticated water buffalo provides India with milk, butterfat, meat, dung for fuel and fertilizer, a cheap alternative to truck or tractor, and enough leather for a shop of sandals.

If the water buffalo wasn't so ugly and a mite tetchy, with a natural preponderance to spend quality time wallowing in water, it would have a better case than the man-eating tiger for being India's national animal. ∎

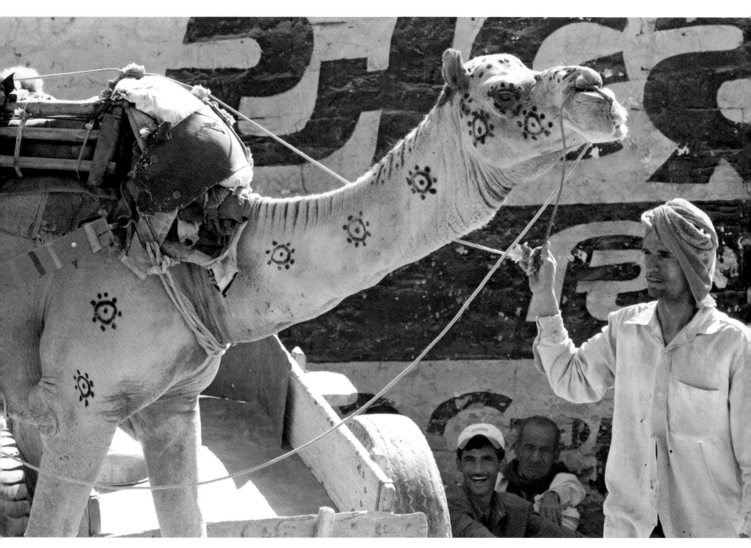

A camel awaits haulage work outside a factory—tattooing is not only decorative but also acts a means of animal identification. Bhuj, Gujarat.

CAMELS

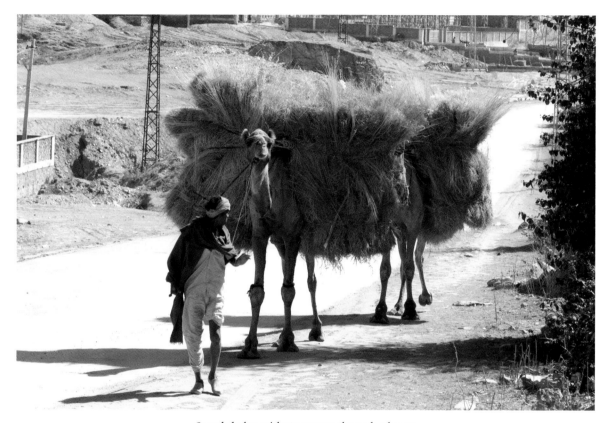

Camels laden with straw pass through a barren landscape. Near Udaipur, Rajasthan.

C

Natural selection has honed the dromedary camel, cruelly tagged as a horse designed by committee, with the rare ability to tolerate a variance in body temperature from 93 degrees at night to 106 degrees in the day. An added bonus is the camel's natural ability to drink forty gallons of water at a time to lessen the risk of dehydration. Given such qualities, camels provide 200,000 Indians living in the arid northwest with a vital source of milk, meat, hair, and haulage (they can carry loads up to a thousand pounds over short distances).

The truth is, if a committee had to design a creature for such a role in such conditions, they'd probably come up with the horse. ∎

25

CASTE SYSTEM

Though discrimination based on caste is outlawed by the Indian constitution, the caste system—a feudal anachronism that gives India a bad name, and is a major obstacle to social progress and economic development—remains deeply entrenched in rural areas, and to a lesser extent in cities.

The four main castes are Brahmin (priests, teachers, and scholars), Kshatriya (kings and warriors), Vaishya (traders), and Shudra (farmers, craftsmen, and service providers). While these main groups may be subdivided into endless mini-castes, it is the fate of the poverty-stricken Dalits—or Untouchables, as the West calls them—that the modern world finds so disturbing. Mahatma Gandhi chose to call them Harijans ("Children of God"), but now the term is considered patronizing and a punishable offense in India, where they are officially known as the Scheduled Caste.

Such niceties of nomenclature mean little to the Dalits, who traditionally are viewed either as the lower orders of the Shudra caste or even outside the caste system altogether. Confined to degrading or polluting work, Dalits have historically often been denied access to temples and shared water. Additionally, Dalits were forbidden from interacting with other castes. Even today, 340,000 are officially recognized as "manual scavengers," causing a growing number to join India's 6 million Buddhists.

The class-ridden British colonials saw bureaucratic merit in the caste system and tried to codify it in India. The British legacy of a ruling order dominated by a Brahmin and upper-class minority, however, still maintains a stranglehold on a nation that desperately needs a meritocracy to tap the vast talent pool of the other 85 percent. ∎

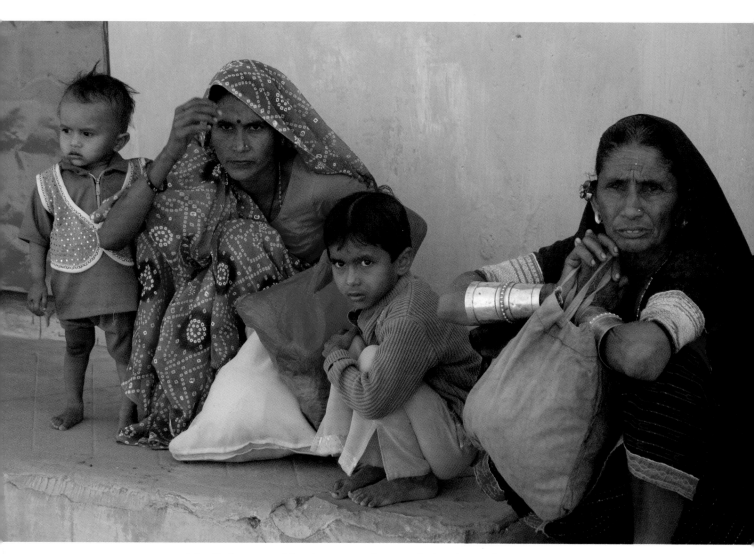

A family from a rural farming community near Bhuj, Gujarat, where caste still dictates the inhabitants' lives, statuses, and futures.

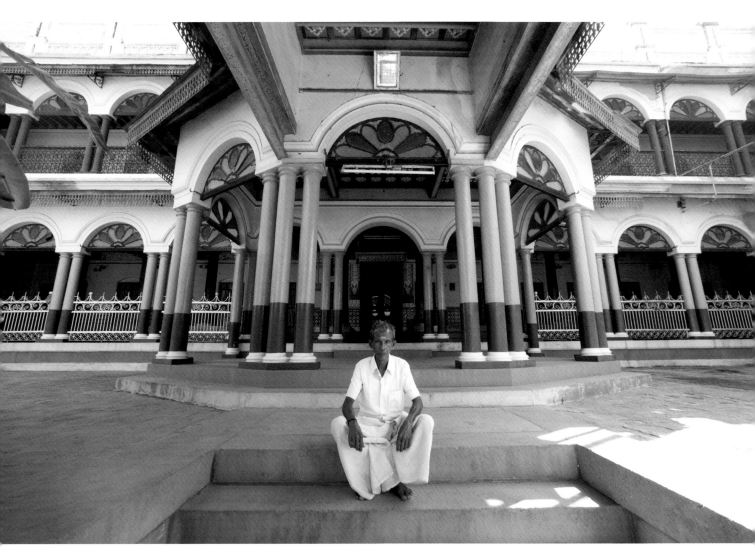

A janitor sits on the steps of his deserted Chettinad mansion.
Kanadukathan, Tamil Nadu.

CHETTINARS

Recognized for their acumen in business, the Chettinars were a caste of Indian traders who spread their trade east into Asia, dominating the teak trade for many years.

With their wealth, the Chettinars built magnificent mansions within a cluster of seventy-odd villages in Tamil Nadu, employing teak, rosewood, and the best architectural features encountered on their travels.

Partially due to their pro-British stance, the Chettinars dispersed, but their mansions remain, standing eerily in dusty rural settings. Some are in disrepair and abandoned to the local wildlife, while others are maintained in pristine order and guarded by solitary janitors who will guide you around these glorious, grandiose homes, some of which may only see their owners once a year for a wedding or party.

One guide stopped at two studded teak doors, explaining that behind one was the family silver, behind the other, their jewelry. I raised a fifty-rupee eyebrow, but he shook his head. Each door, he explained, could only be opened by seven separate keys, held by seven brothers.

Hotel chains are circling, smelling the tourist potential. Go now. ∎

A female janitor sits among the traditional teak columns surrounding the inner courtyard of a Chettinad mansion. Kanadukathan, Tamil Nadu.

CHILI PEPPERS

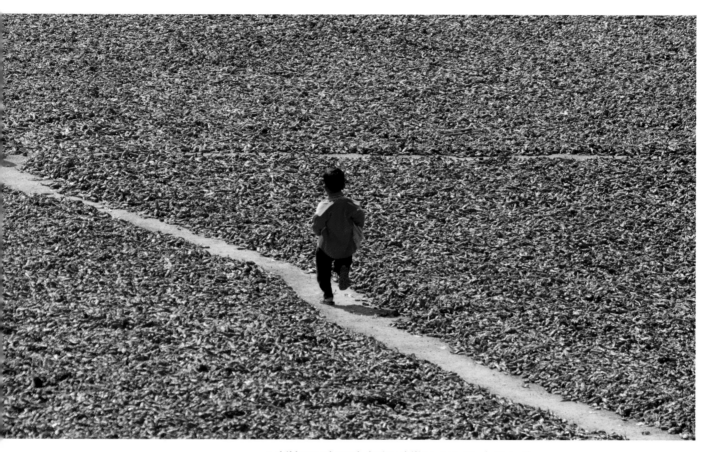

A child runs through drying chili peppers. Tonk, Rajasthan.

Vasco da Gama brought the chili pepper to India (via Christopher Columbus), which now produces 25 percent of the world's supply, with an annual production of around one million tons. It is the fruit of plants from the genus *Capsicum* and, appropriately, a member of the nightshade family.

The *bhut jolokia* pepper from Assam has been named as the world's hottest, measuring 1,001,304 units on the official Scoville Organoleptic Test, compared with the basic jalapeno's 2,500–8,000 rating. ∎

CIGARETTES

One hundred and twenty million Indians smoke *beedis* (or *bidis*), cigarettes made from tobacco rolled in leaves from the *tendu* tree and tied with thread in a cottage industry heavily dependent upon child labor.

Compared with a Western cigarette, a *beedi* contains five times the tar and three times the nicotine, and produces three times as much carbon monoxide. *Beedi* smokers shave six years off their life expectancy and account for 900,000 deaths a year—20 percent of all adult male deaths. Though India's national government has outlawed smoking in public places and banned all tobacco advertising, it is still struggling to reduce these figures. ■

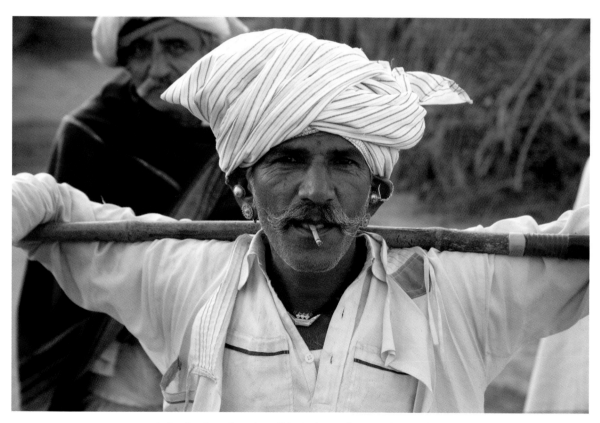

A shepherd smokes a beedi *in Gujarat, the state that produces the strongest of tobaccos. Little Rann of Kutch.*

COCONUT PALM

The coconut palm is a mainstay of the Indian economy, serving many functions: palm fronds are used for thatching and weaving; white coconut meat can be eaten raw, and it is often used in cooking or converted to oil; coconut water and the milk produced from the coconut fruit are both popular drinks; and the husk fiber is converted to coir for rope and matting.

In Sanskrit, the coconut palm is called *kalpa vriksha*, "the tree providing all life's necessities," supporting the theory that if you are shipwrecked on a desert island covered only in coconut palms, you will have all necessary ingredients for survival until rescue arrives. Should the palms include the genus *Palmyra*, do as the Indians do and ferment the toddy sap into the potent drink *arrack*—thus rendering rescue irrelevant. ■

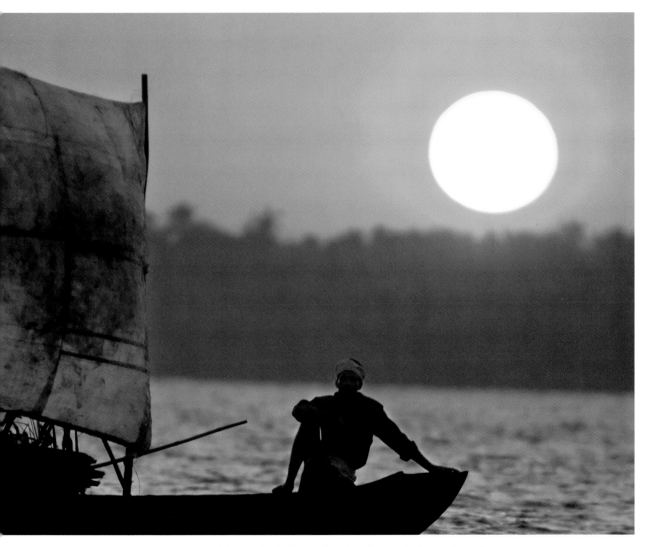

At dusk, a load of palm fronds sail across Lake Vembanad. Kumarakom, Kerala.

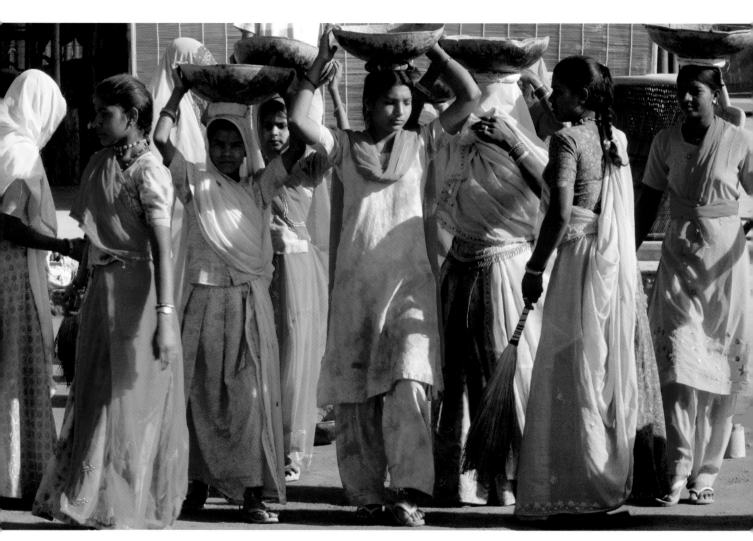

*This is neither a wedding party, a festival, nor a fashion show, but a female work gang laying
fresh mud at a camp compound. Their garments reveal India's glorious, impulsive addiction to color—
a cultural trademark that lightens their lives and ours. Nimaj, Rajasthan.*

CORRUPTION & CRIME

On the outskirts of Varanasi, Uttar Pradesh, an armed traffic cop demands a bribe from a truck driver—a regular occurrence throughout India.

The driver will plead that his boss makes no allowance for such payments, and the cop will hold his ground as traffic backs up, until a deal is struck: a cut will go to the cop's boss, who passes along another cut to *his* boss, and onward and upward until you believe the estimated $5.3 billion paid in bribes each year to keep freight on the move.

With black money in circulation probably exceeding legitimate currency, Indian corruption is invasive and endemic, crossing all class and caste divides. Rampant corruption is a massive strain on economic growth that has created a morality of acceptance. 90 percent of the population believes corruption is growing, with police and politicians the most corrupt of all, giving credence to the estimate by Rahul Gandhi (grandson of Prime Minister Indira Gandhi) that only 5 percent of development funds ever reach the intended parties and echoing the Chinese proverb that "Fish rot from the head down."

Equally depressing are the 2006 figures for reported crime: 32,481 murders, 19,348 rapes, 36,617 molestations, 7,618 dowry deaths, 2,000 kidnappings, and human trafficking in 60 percent of Indian states (largely responsible for creating India's four million prostitutes). *Reported* is the operative word, as corrupt and lethargic police practices, apathy for the plight of lower castes, and female subjugation all combine to hide the true reality.

Despite such figures, however, we have never felt safer anywhere in the world. ∎

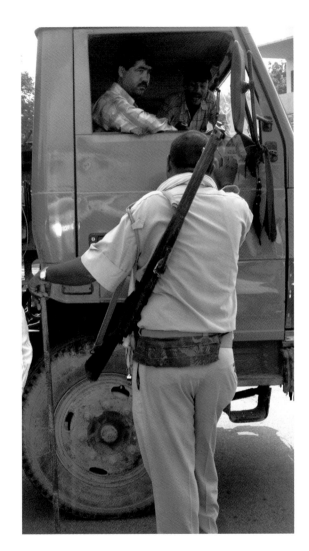

COWS

Indian cows face mixed fortunes.

The lucky ones are revered as sacred by most Hindus and given carte blanche to wander free from hindrance or harm. While this may have a certain quaintness in rural India, free-roaming cows prove a ludicrous anachronism as they graze on garbage in traffic-clogged city streets. (It's been recorded that Delhi cows have on average 300 plastic bags in their stomachs.)

The unlucky ones spend their lives pulling—plows, carts, water wheels, you name it—and are called oxen.

And the really unlucky ones are the oxen who, after a life of hard labor, end up in one of India's 30,000 illegal slaughterhouses. ■

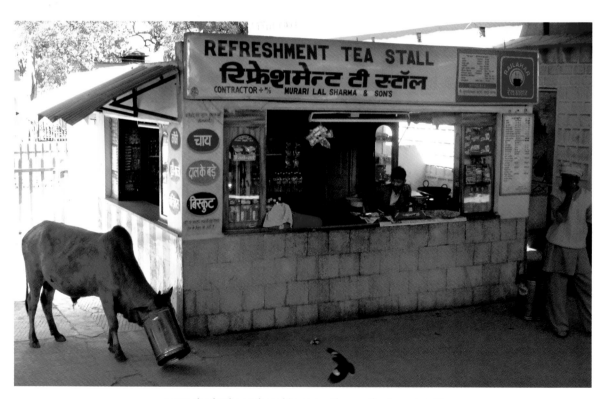

A cow checks the garbage bin at a railway refreshment stall.
Sawai Madhopur, Rajasthan.

36

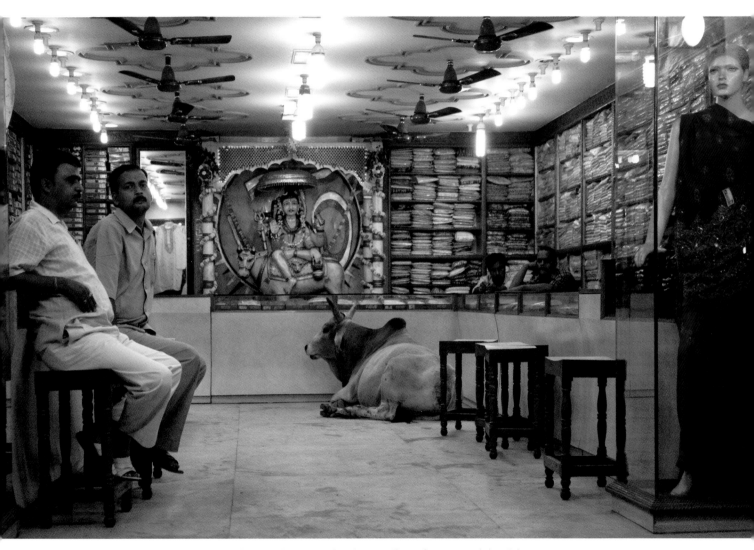

Each evening this sacred cow wanders into a tailor's shop to spend the night,
leaving each morning to pick over city garbage. Varanasi, Uttar Pradesh.

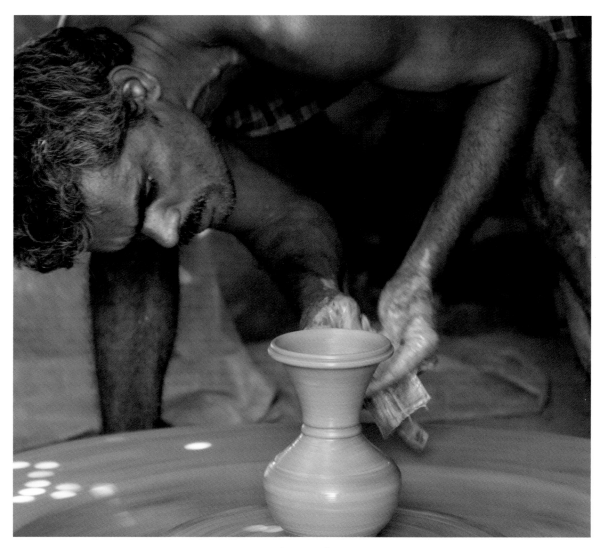

A potter throws a clay vase.
Near Madurai, Tamil Nadu.

CRAFTS

While industrialization and mechanization barrel ahead, the crafts of rural India remain a riveting living museum of skills last seen by our grandparents.

A combination of handed-down know-how, life-long practice, and improvisation born of necessity results in a mesmerizing degree of expertise in these craftsmen.

There may be a million of these dollar-a-day no-bodies, but fly any of them to the West, and he'd be a state fair sensation. ∎

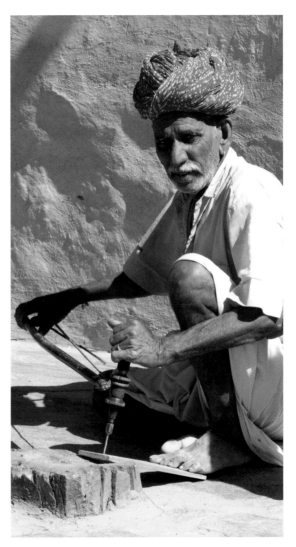

A village carpenter uses a crude bow drill, his feet serving as a vise. Nimaj, Rajasthan.

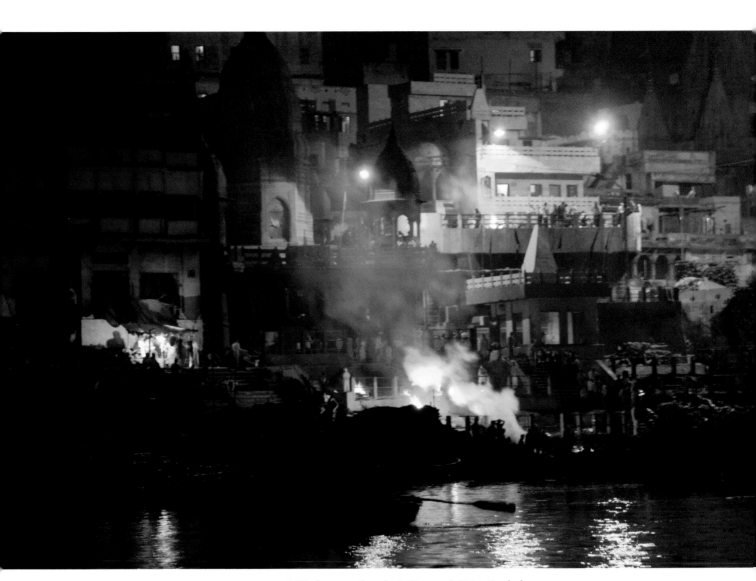

A Hindu cremation ghat, Varanasi, Uttar Pradesh.

CREMATION

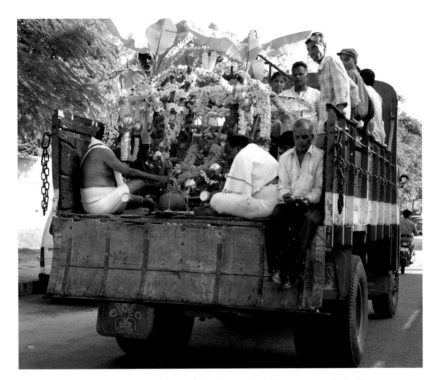

*A construction truck rumbles through traffic carrying the body
of a deceased woman, borne on a bamboo stretcher decorated with garlands
and banana leaves, bound for her cremation. Mysore, Karnataka.*

A Hindu's body is ceremoniously burned on a wood pyre in a Varanasi cremation *ghat* (a broad flight of steps down to a river). Forty thousand such cremations take place each year. Butter oil is used to ignite the timber—sandalwood for the rich, and mango wood in Kerala—but with lumber in short supply, the poor are often sent on their way with a fire fueled with cow manure, while the poorest might be floated off into rivers.

The body might take six hours to be reduced to ashes; if the skull does not explode with the heat, then it must be smashed by a chief mourner to release the deceased's soul.

The next morning, the ashes are sifted through to retrieve any jewelry that may have been left on the bodies. ∎

41

CRICKET

In 2007, ESPN-Star Sports TV Network (jointly owned by Rupert Murdoch and Disney) paid $1.1 billion for the right to show international cricket events like the World Cup until 2015. A year later the Indian Cricket Board's Twenty20 League negotiated a ten-year contract with Sony Entertainment for another $1 billion.

If such figures seem extraordinary for a convoluted sport that is almost inexplicable to Chinese or Americans, consider that a televised international match featuring India's team draws 450 million viewers. Cricket in India is closer to a quasi-religion than a sport, uniting the nation like nothing else.

Yet cricket draws a fickle following that demands success; cricketers are only as good as their last match, and they are treated either as gods or targets of rotten fruit accordingly, particularly when returning from games abroad. The intensity with which players are judged is perhaps connected to the fact that vast illegal sums may be wagered on any aspect of a game via young runners; the betting slips are later destroyed to eliminate paper trails.

Oddly, India still claims hockey as its national game. ∎

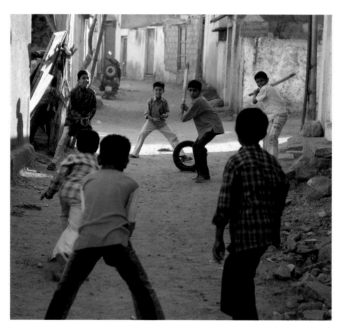

Using a scooter wheel as wicket, two village batsmen line up for the same ball. Nirona, Gujarat.

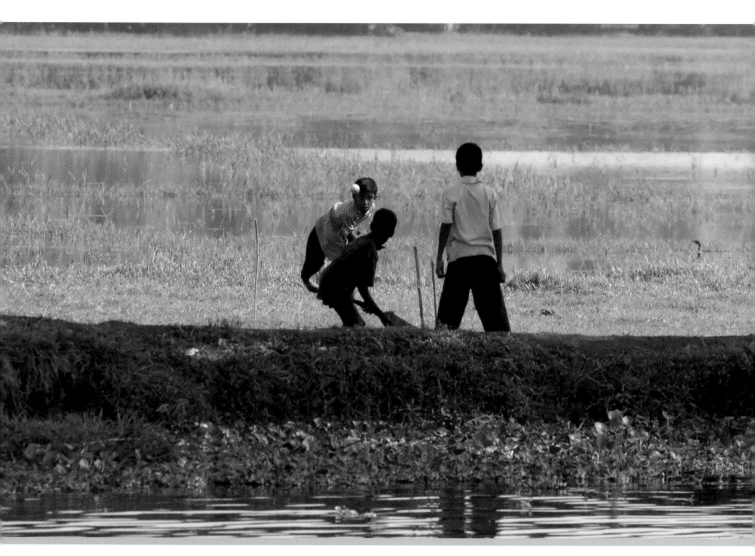

*On a strip of dry land barely ten yards wide, bound by the backwaters on one side and a rice paddy
on the other, boys play a precarious game of cricket. Near Kottayan, Kerala.*

43

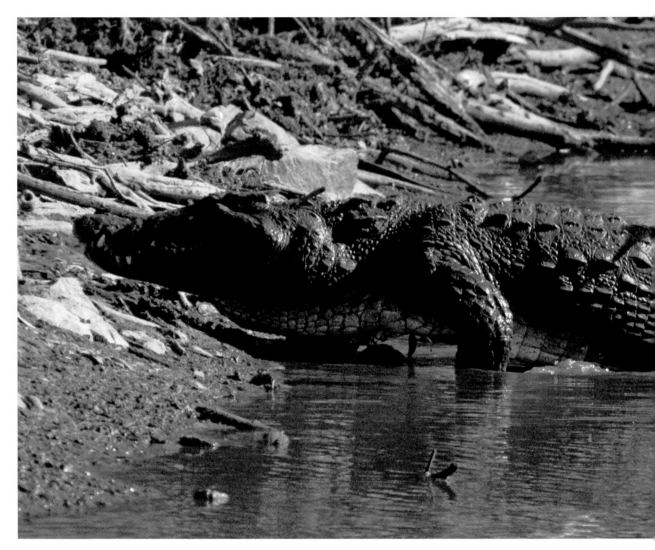

A bold egret rides a crocodile as it leaves a lagoon.
Ranthambore, Rajasthan.

CROCODILES

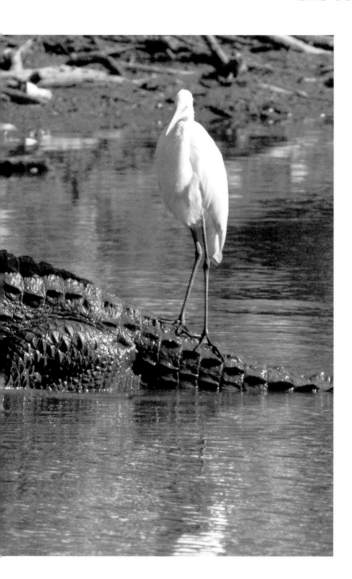

Barely changed since the age of the dinosaurs, crocodiles have little need for evolutionary improvement: they are perfect killing machines and masters of the surprise strike, with a bite force of 5,000 pounds per square inch (compared with the rottweiler's puny 330-pound bite).

If the crocodile has a weakness, it would be the muscles that open the jaws—these can be held shut with a strip of rubber from an automobile inner tube.

The saltwater crocodile, as wrestled by Tarzan, is widespread throughout India and known to attack humans—nervous visitors might stick to Kerala and Tamil Nadu, where they're extinct, or elsewhere give a wide berth to floating logs with nostrils. ■

DABBAWALLAHS

D

Dabbawallahs *rush a basket of sorted lunch boxes from Churchgate Station for delivery to the city center.*

Every working day, 170,000 Mumbai housewives pack hot lunches into lunch boxes that are then collected—at a cost of around five dollars a month—and delivered to their husbands working in the city center by an army of five thousand *dabbawallahs*. These delivery men take the train to Churchgate Station, where, balancing forty on his head in a basket that weighs up to two hundred pounds, each man carries his load through the lunch-hour chaos of a divided highway to be sorted and redistributed on the other side to fresh relays, who deliver the tins to their final destination by cart, bicycle, or on foot.

The *wallahs*, all from related families near Pune, are mainly illiterate, so they color-code each lunch box with dots, dashes, crosses, and colored ribbon to indicate areas, streets, buildings, floor levels, and offices.

Though it appears chaotic, only one box goes astray for every six million deliveries in this city of sixteen million people, earning them the world's highest business efficiency rating of Sigma 6 by *Forbes* magazine. With its impressive distribution logistics, the *dabbawallah* lunch-box delivery system is the subject of business school seminars. ■

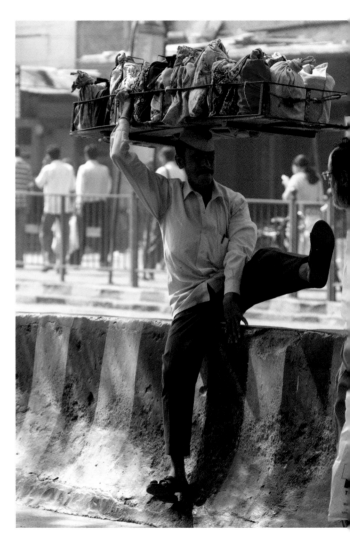

A dabbawallah *hurdles the median road divide outside Churchgate Station with forty Tiffin tins on his head. Mumbai.*

DHOBI WALLAHS

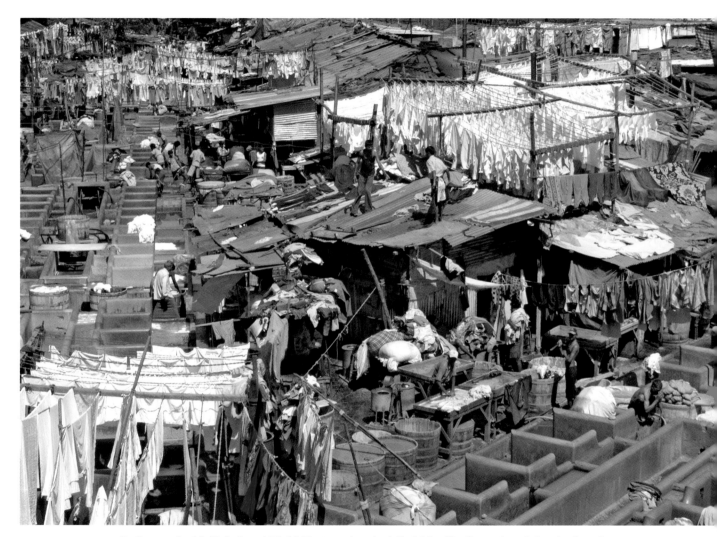

In the ramshackle Mahalaxmi Dhobi Ghat, two hundred dhobi families live and work, beating laundry in a series of concrete wash pens, immersing it in giant vats of boiling starch, hanging it to dry, and finally pressing the garments with wood-burning irons before delivering for a few rupees per item. Mumbai.

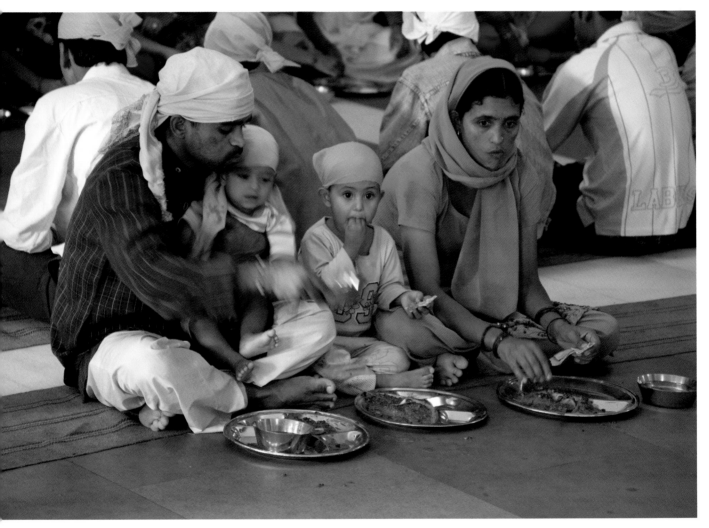

A family visiting the Golden Temple eats a lunch of dhal *and* dhosas
*in a communal hall where up to ten thousand such meals for visiting pilgrims
are prepared daily by volunteers. Amritsar, Punjab.*

DIET

Influenced by a multitude of invading cultures, Indian cuisine is one of the most diverse in the world; based on rice, whole-wheat flour, and pulses, it's characterized by the judicious use of spices and herbs. Though one-third of Indians are vegetarian, many traditional dishes use meat and fish.

While tourist menus are liberally sprinkled with "traditional" and "authentic" dishes, these are probably not what your waiter might eat at home.

Our first taste of the genuine article came in Tanjore, Tamil Nadu, when we offered to buy dinner for our guide and driver at the restaurant of their choice, which proved to be a mud-floored hall. The harassed waiter apologized for delays, explaining that their six regular chefs had been given time off after long hours during the festival of Diwali, and their stand-ins were being hard pressed by the full house.

So we finished two bottles of mineral water while watching the temporary chefs stir vast vats with paddle oars before large banana leaves were laid before us and spread with pyramids of rice and angel hair pasta, encircled with a dozen home-made dipping sauces, bowls of *dhal* and *dhosa* pancakes, followed by sweet milk for dessert. Afterward, the waiter politely asked us why we couldn't finish it all and presented a bill of $3 for all four meals. ∎

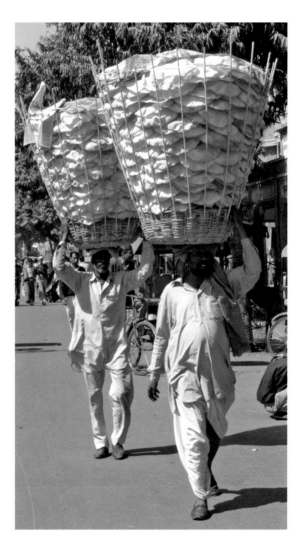

Poppadum *supplies arrive in the city center. Jaipur, Rajasthan.*

DONKEYS

Lacking spiritual status or the strength and load capacity of other draft animals, the donkey is probably the most neglected of livestock creatures in India.

Our guide, having shown us Asia's largest carpet and Asia's largest chandelier during the day, was momentarily at a loss for words when I stopped to photograph this donkey, dozing amid the cacophonous evening traffic that wove around it. Though fresh out of donkey statistics, he was not a man to be beaten and, bending low and shouting in my ear, he revealed that this was Asia's second-most beautiful square. ∎

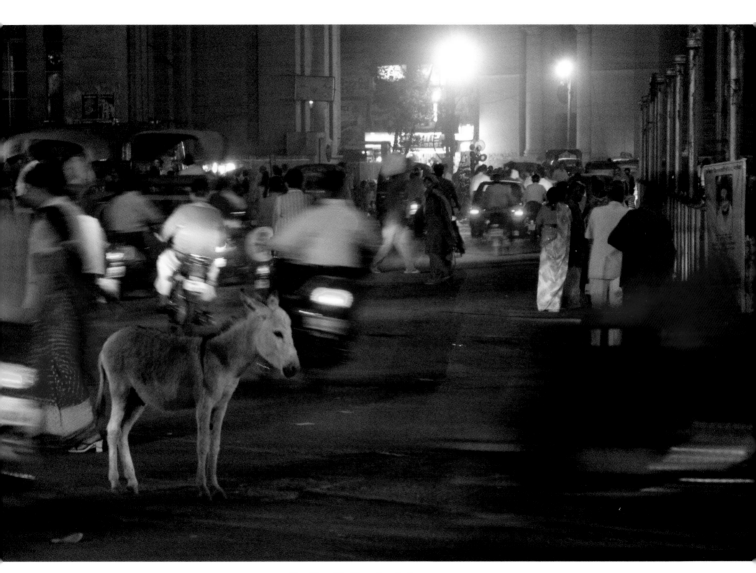

Gwalior, Madhya Pradesh.

DRESS

In a nation beset with social and economic problems, the inevitable decline of national costume in the face of Western influence may be deemed no more than a sadness, yet to see glorious and vibrant traditional garments alongside Western clothing (de rigueur for the young) highlights an aesthetic tragedy. ∎

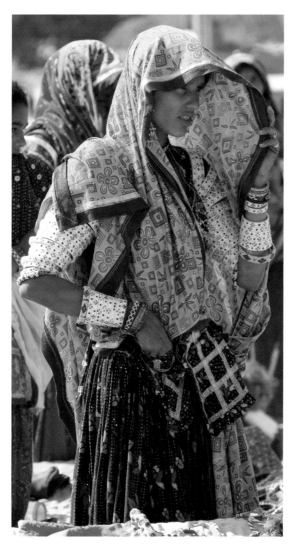

In a nomadic tent village, a young woman is festooned with arm bangles. Dasada, Gujarat.

A woman walks through a Muslim village. Near Bhuj, Gujarat.

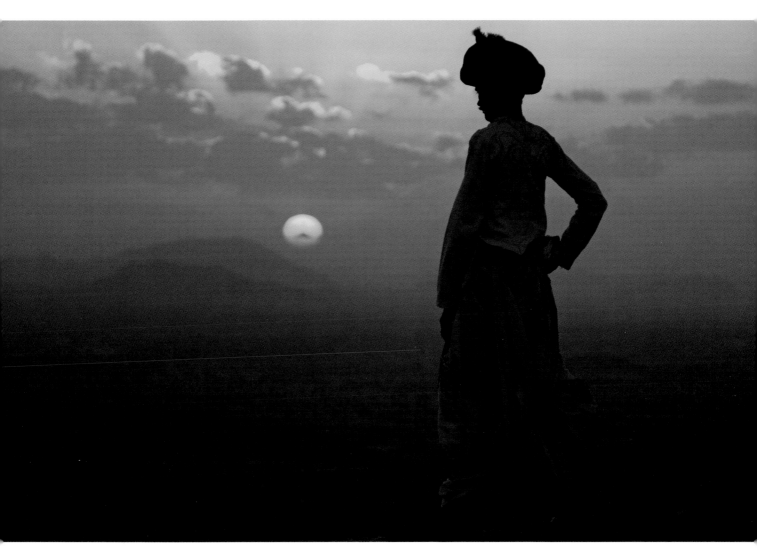

*Wearing traditional local costume, an Indian stands at sunset on a 350-foot
granite rock overlooking the village of Narlai, Rajasthan.*

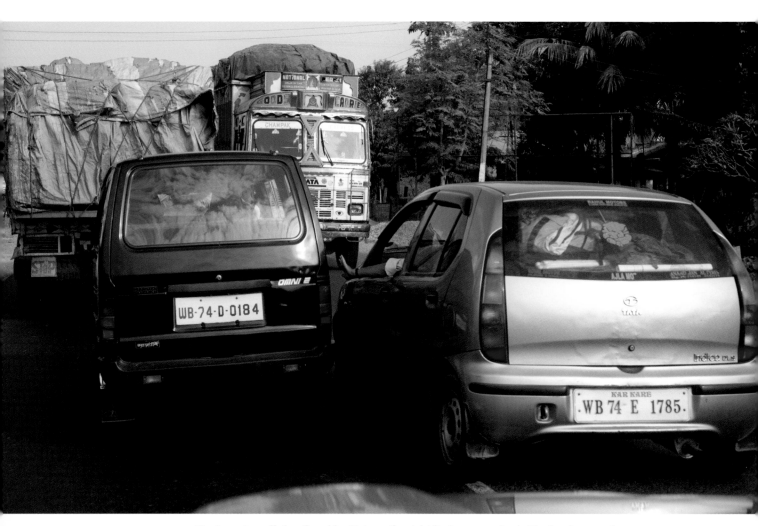

Having cut us off, the silver-blue Tata on the right finds no room to avoid a head-on crash with the oncoming truck at a closing speed of around 50 mph; using the horn to alert the dark blue car to move over is useless, as everyone is using their horn, so his desperate passenger hammers violently on the driver's door. It works, and everyone survives. Near Darjeeling, West Bengal.

DRIVING

Indian driving, combining gentle mayhem with lethal madness, is unique to the subcontinent and best described to noncombatants as stoned yachtsmen weaving for position before a massed-start sailing race.

As a rough primer: not all Indians drive on the left; the use of gears has never been fully mastered; rearview mirrors are intended for checking mustaches; signaling left or right can *either* show an intention to turn *or* advise if it is safe to pass; and the horn is permanently employed because it's there.

Hiring a good driver increases your chances of survival, but there is no way of knowing if the guy barreling toward you bought his license for a few rupees, nor when he last slept, what he last smoked, and whether he has any plans for avoiding you. But of one thing you can be certain—his rating of the importance of safety will be infinitely lower than yours. These problems and attitudes combine to explain why there's a fatal accident on Indian roads every five minutes, accounting for 8 percent of the worldwide total.

To ensure safe journeys, drivers garland vehicles with offerings to their particular gods, stick statues of deities on the dashboard, and even stop to have the car, tires, or ignition keys blessed at wayside temples. (Be patient, it might work—we survived a seven-hour journey to Pondicherry with four lemons tied to our registration plate.)

As for night driving, I've never been so scared outside a combat zone. Indian night driving actually is a combat zone—if you can't get a bed for the night, find a ditch, cover yourself with leaves, and wait for dawn.

And yet, and yet, in six months spent on Indian roads we never experienced an accident, a display of road rage, or even a rude word. It *has* to be the lemons. ∎

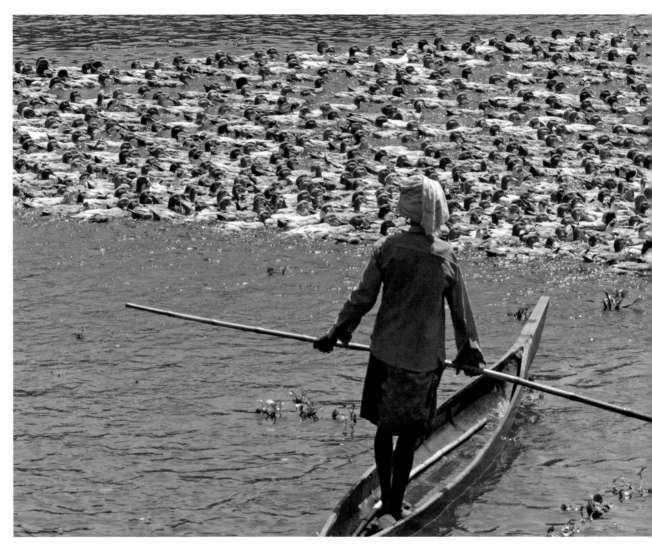

*A solitary farmer punts through the Keralan Backwaters, guiding hundreds
of ducks to freshly harvested paddy fields. Near Alleppey, Kerala.*

DUCK FARMING

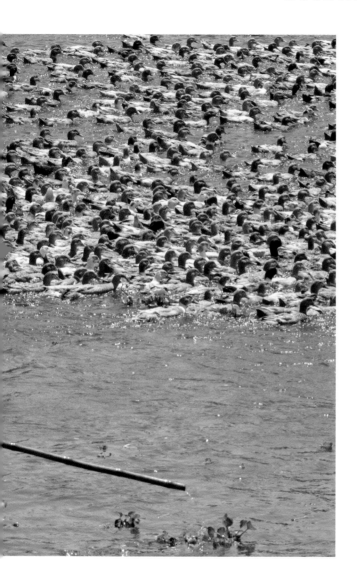

When Keralan duck farmers, who traditionally released their flocks into paddy fields after harvest, found rice farmers switching to better cash crops, they invented duck migration with groups of up to 500 herded slowly through the Backwaters in search of the diminishing paddies, the journeys often taking months at a time. ∎

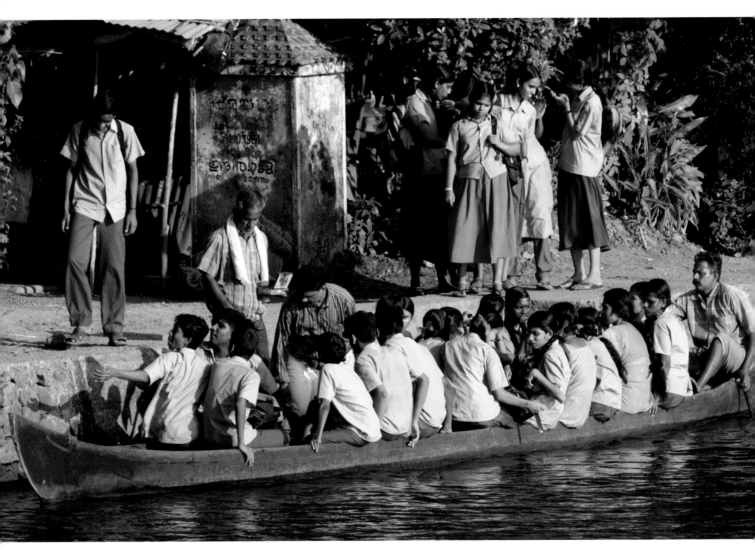

Children leave school by boat in the backwaters of Kerala, which boasts the highest literacy rate of any Indian state, 90 percent.

EDUCATION

It's hard to write on any Indian social subject without mentioning the word paradox, and education is no exception. Forty million primary-school-age children do not attend school (where a quarter of the teaching staff is absent on any given day); 92 percent will not progress to secondary level; the school-leaving age is twelve; and India's illiterate population (which matches India's total population at Independence) represents 35 percent of the world's total. The adult literacy is rate is 61 percent—low compared with China's 91 percent—while female illiteracy has dropped to 50 percent.

Yet each year India produces one million graduates in engineering alone, ten times the combined total of America and Europe. And India's million-strong engineering brain drain represents a mere 4.3 percent of the country's total graduate population.

While India's economy may boom, not until the country narrows such disparity of education can India begin to think of itself as a great nation. ∎

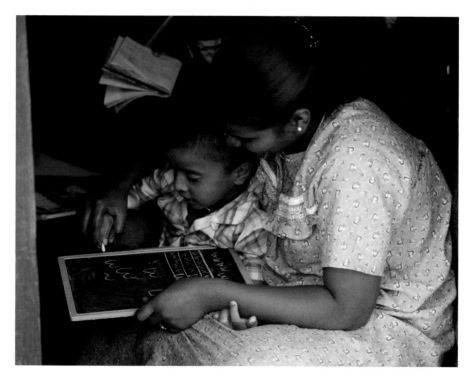

A mother helps her son with basic spelling using a chalk and slate. Karaikudi, Tamil Nadu.

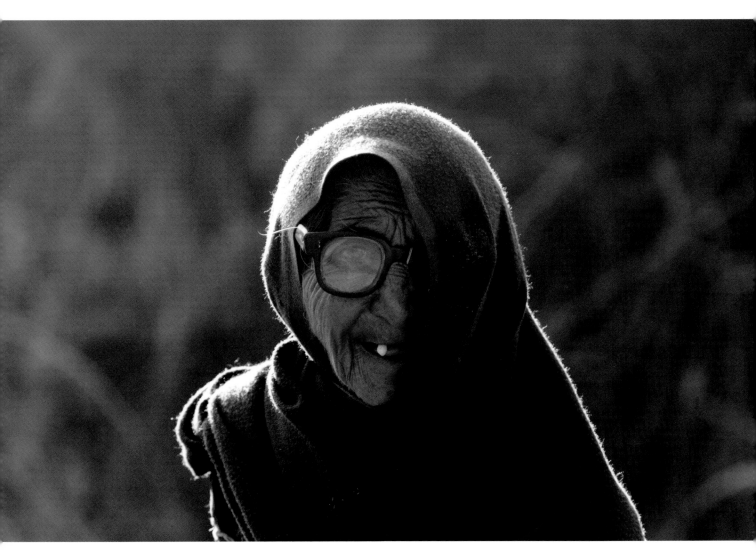

A wizened woman reveals one eye and one tooth from behind her shawl. Little Rann of Kutch, Gujarat.

ELDERLY

India's over-sixty population, now 76 million, will explode in the next twenty years to an estimated 173 million. With the erosion of the traditional Hindu joint family (see "Families"), the subsequent abandonment of the elderly led in 2007 to a parliamentary bill making it obligatory for those who will inherit the property of their elderly relatives to maintain them, with failure to do so punishable by fines, imprisonment, or both.

While admirable in many ways, the bill relieves the state of its own fundamental obligations and may prove impractical to implement. ∎

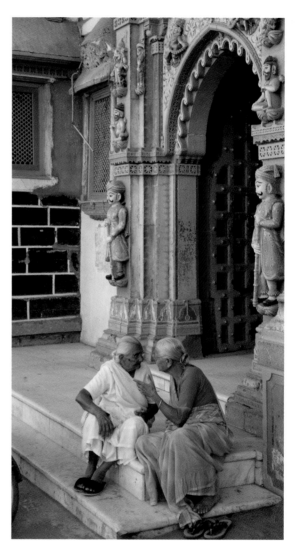

An elderly villager.
Nimaj, Rajasthan.

Two old women chat at the entrance
to a temple. Bhuj, Gujarat.

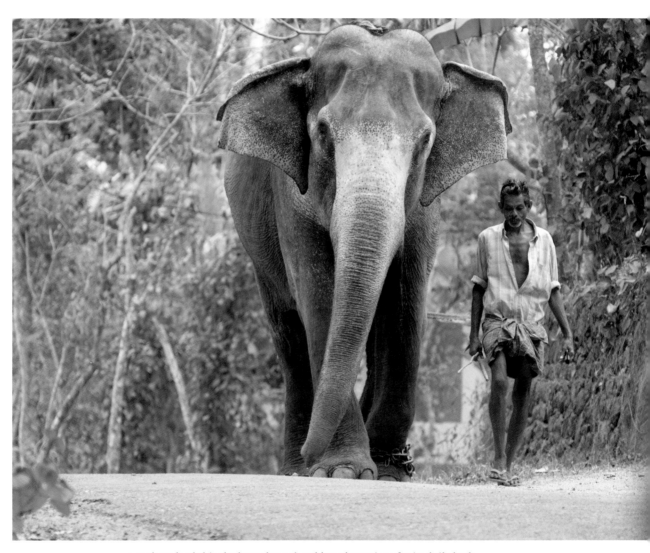

A mahout leads his elephant through rubber plantations for its daily bath.
Near Cochin, Kerala.

ELEPHANTS

India is home to some 28,000 elephants that live in the wild. Spending twenty hours a day eating 10 percent of its body weight, the Indian elephant uses six sets of teeth over its sixty-year life span.

India also has about 3,800 elephants in captivity, 800 of them in the state of Kerala, where they are most revered. Festooned with richly embroidered caparisons, they take pride of place in festivals and religious ceremonies. Many Hindu temples have their own elephants, donated by devotees.

Though such reverence may reflect the elephant's esteemed position in Hindu religion, it doesn't always extend to their treatment; elephants are often cruelly trained by mahouts and illegally forced to walk long distances on hot roads by owners keen to exploit their potential during the festive seasons. ∎

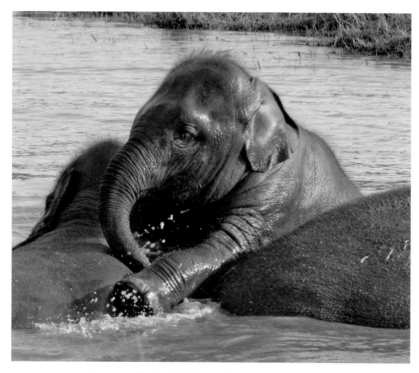

A young elephant bathes with its parents after their day's work. Bandhavgarh, Madhya Pradesh.

FAMILIES

F Traditionally, the Hindu joint family, or, officially, Hindu Undivided Family (HUF), includes everyone descended from a common ancestor living under one roof (plus their wives and unmarried daughters). This family unit is joint not only in its common estate but in most aspects of life.

In this patriarchal society, it usually falls upon the eldest male to run the family, settle disputes, and be solely liable (under Hindu law) for any business run by the joint family. This family business structure causes most familial disputes and splits, thus contributing to the gradual eradication of the system.

Despite such erosion of the joint family, religious and spiritual influences continue to exert a strong effect on most Indian families. ∎

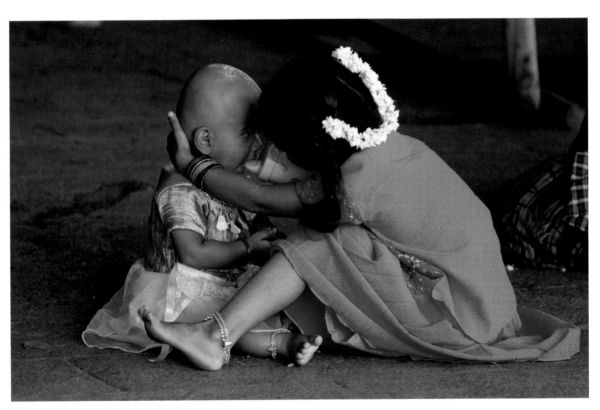

The daughter of a family of pilgrims feeds a young sibling (with a traditionally shaven head) as they rest in a temple complex. Trichy, Tamil Nadu.

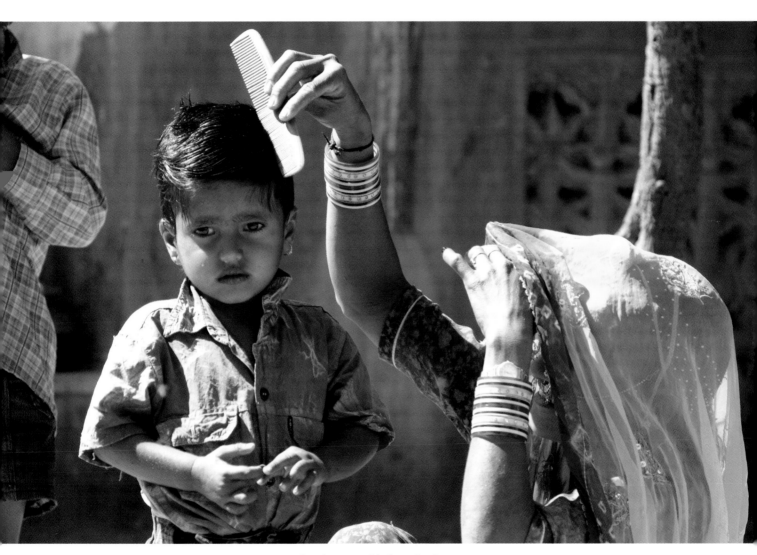

A grandson is groomed before school.
Narlai, Rajasthan.

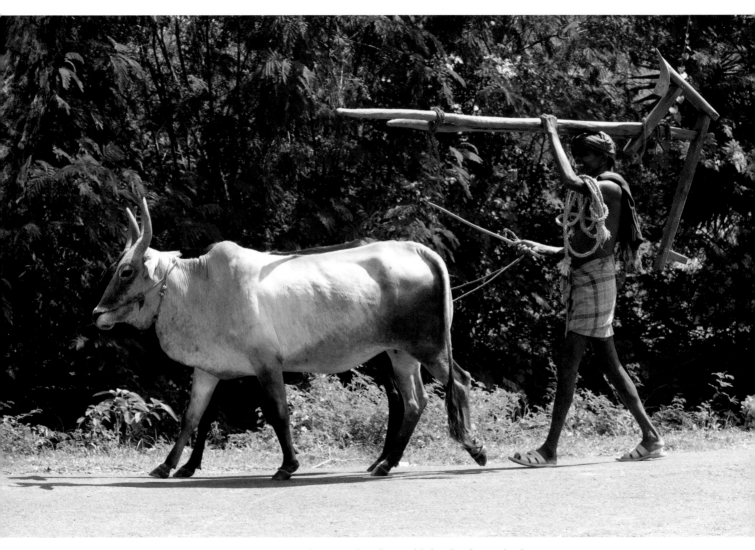

Carrying a wooden plow on his head, a farmer leads
his cattle from a field. Near Madurai, Tamil Nadu.

FARMING

Every day for the past decade, on average forty Indian farmers have committed suicide. Though such figures are blandly blamed on individuals failing to meet money-lending debts, other factors that have contributed to farmers' grinding lot include lack of government support, low market prices, outdated husbandry, urban migration, and lethally erratic monsoons. (In this land of wooden plows, there are six tractors for every thousand agricultural workers, compared with the United States' 1,586 tractors per thousand workers.)

As agriculture has only been able to increase staple food production by 1 percent while population has grown at the rate of 1.5 percent, India faces the possibility of being unable to feed itself. In March 2008 the government announced a $15 billion loan waiver scheme to help thirty million small farmers, and a one-time loan settlement for ten million more.

Yet as long as the evils of high-interest lending and bonded labor remain entrenched, it will take more than genetically modified crops, irrigation schemes, and government loans to lower the suicide rate of Indian farmers.　■

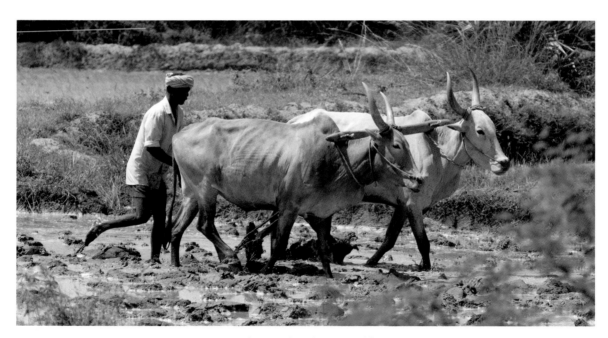

A farmer plows his rice paddy.
Near Karaikudi, Tamil Nadu.

FESTIVALS

Indians celebrate festivals at the drop of a hat—understandably, given the grinding poverty and heavy workload that is so often their everyday lot—creating a plethora of holidays that threaten to create calendar gridlock.

Diwali, or the Festival of Light, is the most popular; any form of light signifies the triumph of good over evil, and celebrants make special prayers to Lakshmi, the Hindu goddess of wealth, for a good year to come.

Every spring, half the nation celebrates Holi, the two-day Hindu Festival of Colors. Bonfires are lit on the first night, but the festival really kicks off the next morning when the joyous celebrants daub themselves with highly colored powders and then spend the day throwing bucketfuls of colored powder at anyone within range. The mythological basis for this custom varies between regions, but who needs an excuse to splatter friends, family, and complete strangers? It's national paintball!

Traditionally, the colors are organic, but authorities now warn of synthetics creeping in. When we were caught up in the Holi madness on the last day of a recent trip, the colors I acquired resisted painful scrubbing in a Delhi hotel, so I set off for the airport with a scarlet face set off by pink highlights in my hair. ∎

Workmen take a break from decorating one of the giant wooden chariots in an annual festival parade. Kumbakonam, Tamil Nadu.

Assailants in Delhi celebrate Holi
with a direct hit on our car.

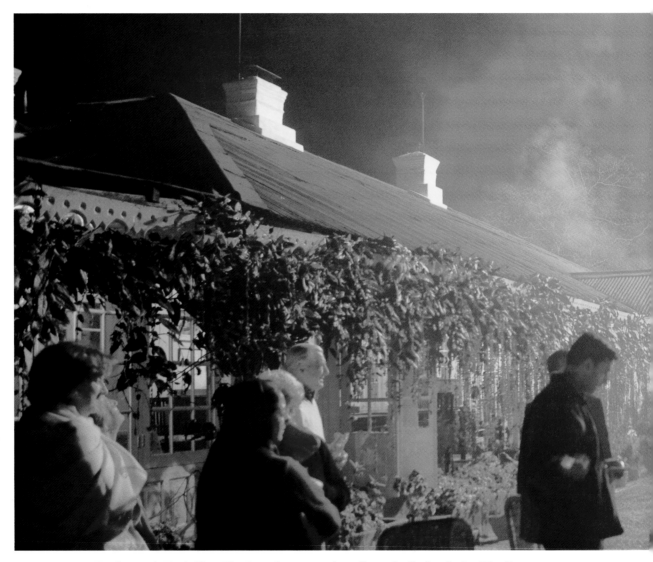

Hotel guests in Darjeeling, West Bengal, are treated to a fireworks display during Diwali.

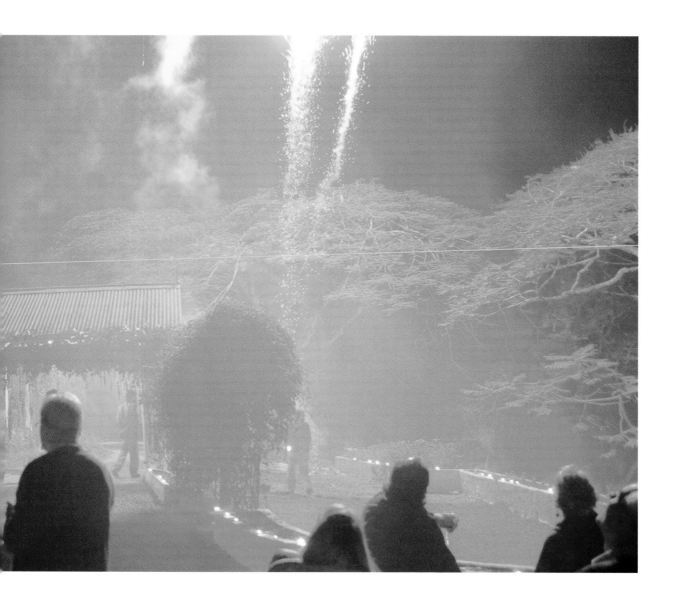

FISHING

Chinese Nets

Watching Kerala's Chinese fishing nets in action is hypnotic. These shore-based wooden cantilevered structures (up to thirty feet in height) are held together with Fred Flintstone joinery, yet so finely balanced that one man walking up a main strut will cause their vast horizontal net to dip into the sea before the rest of the gang pulls it up by ropes counterweighted with boulders big enough to kill, yet tied with crude knots. The operation may be repeated 200 times each session, as the licensed nets are pitched at different heights, and capturing many of the passing fish.

Catches vary from sprats that would not cover the palm of a hand to thrashing specimens that might be sold on the spot to locals or to small local cafés.

Whatever the catch, these fishermen take it in stride—they've been doing it all their adult lives, and it's just another day. ∎

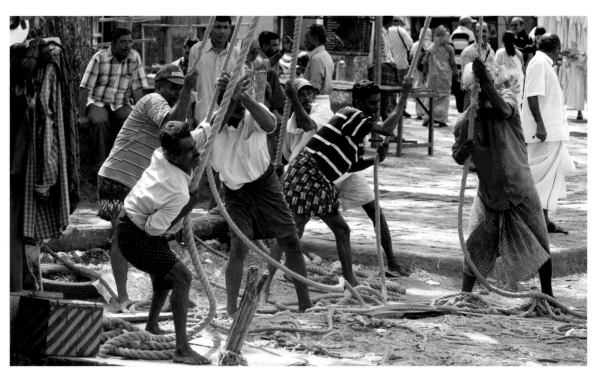

A gang of fishermen work the ropes of
their Chinese nets. Cochin, Kerala.

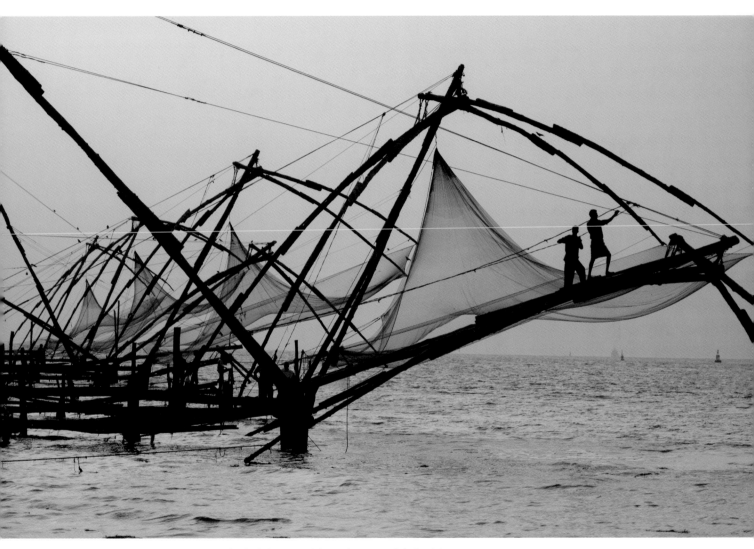

*At dusk, fishermen tighten the ropes of their Chinese nets
in readiness for the morning session. Cochin, Kerala.*

73

FISHING

Coastal

Two old men stand at dawn on a rocky promontory, shouting above the roar of the surf as they examine the surface of the Arabian Sea for any sign of fish.

Suddenly there's wild gesticulating, and the twelve-oar longboat riding the swell is guided to a possible shoal, where the village fishermen cast their four-hundred-yard-long floating net.

Soon rhythmic chanting begins as two lines of men on the beach, their bodies almost horizontal with the strain, start pulling in the net, gaining momentum as the arc of net closes in on the shore. But instead of the thrashing load you expect, there is just a brown coil of net, which they unravel to reveal a catch of fish no bigger than a man's fist.

Like the fishermen who operate the Chinese nets, the men register no disappointment or emotion, just a murmur and the odd glance at one another. Then there's more shouting from the old men, the longboat is relaunched, and the process starts anew.

In the absence of refrigerated transportation, the market for these fish, which often represents the sole livelihood of such coastal villages, is limited.

A lot rests on the shoulders of those old men on the rocks. ∎

*Even if the day's catch is poor, few fish
are too small to eat. Benaulim, Goa.*

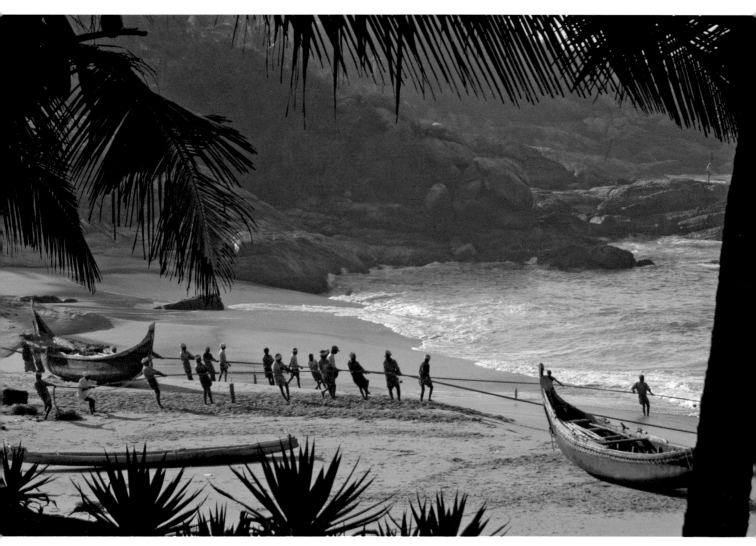

*Chanting villagers pull the fishing net—all four hundred
yards of it—onto the beach. Pulinkudi, Kerala.*

FISHING

Inland

In the Keralan backwaters, fishing can vary from precarious seven-man wooden canoes to the bow fisherman. ∎

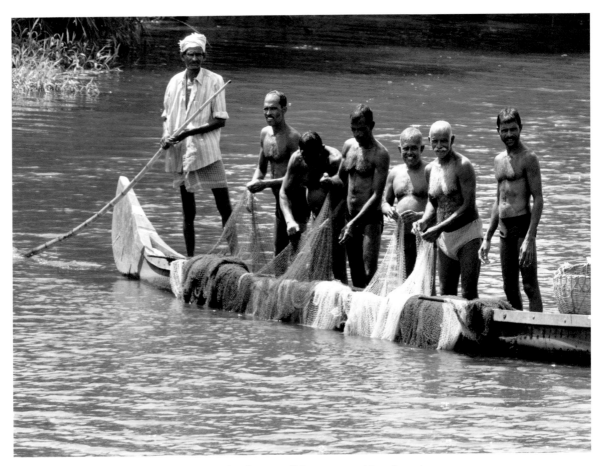

Balanced precariously, seven fishermen stand in a dugout canoe and repair their nets. Keralan backwaters.

With his crude bow and arrow, this archer fisherman may know little of the theory of refraction, but he can still skewer enough to make a living. Keralan backwaters.

G

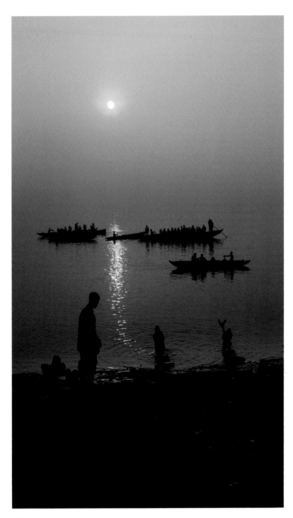

India's holiest river, the Ganges, rises in the southern slopes of the Himalayas and runs 1,500 miles east before draining into the Bay of Bengal; its fertile basin is vital not only to the economy but also to the lives and livelihood of nearly half a billion people. A United Nations report suggests that the glaciers that feed the river may dry up by 2030; if true, this would make the Ganges's flow seasonal, dependent on monsoons—and it would disrupt life along the riverbanks.

Though worshipped by Hindus—thousands of pilgrims wash in the Ganges as it passes through the holy towns of Haridwar, Allahabad, and Varanasi, in a bid to absolve sins and break the cycle of reincarnation—the Ganges in reality is a sick river. Its pollution by raw sewage, human and animal corpses, and industrial poisons has reached such grotesque levels that thousands of holy men vowed to boycott the 2007 Hindu festival of Purna Kumbh Mela (held every six years), when up to 70 million pilgrims bathe in the river. Most Indians are unaware that an estimated 80 percent of the nation's health problems and one-third of its deaths can be attributed to waterborne diseases. ∎

As the sun rises over the Ganges, dhobi wallahs pound laundry against rocks. "That is bedding from boarding houses and hostels," our guide assures us, "not from good hotels." Varanasi, Uttar Pradesh.

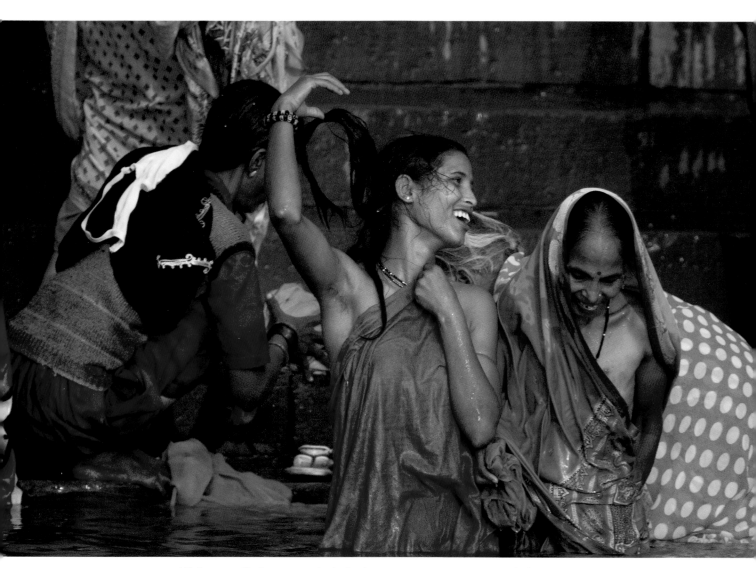

Oblivious to pollution, women bathe in the Ganges. Varanasi, Uttar Pradesh.

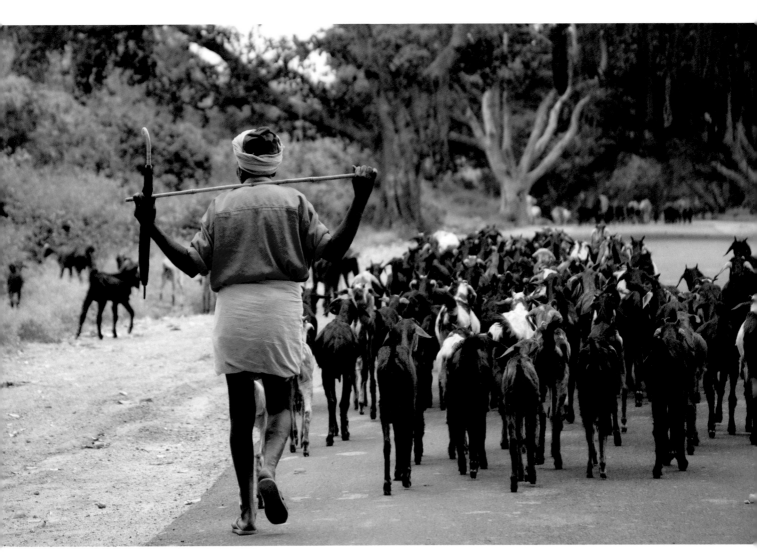

A farmer remembers his rolled umbrella as he drives
his goats to fresh ground. Bannur, Karnataka.

GOATS

With their ability to endure harsh conditions, India's 100 million goats have proved an economic mainstay of villages and an insurance against disasters. Rightly dubbed the poor man's cow by Gandhi, the goat provides a sure secondary income alongside more vulnerable crops. Hindus do not place religious restrictions on the slaughter and consumption of goats, which provide cheap meat and can be milked several times a day. ∎

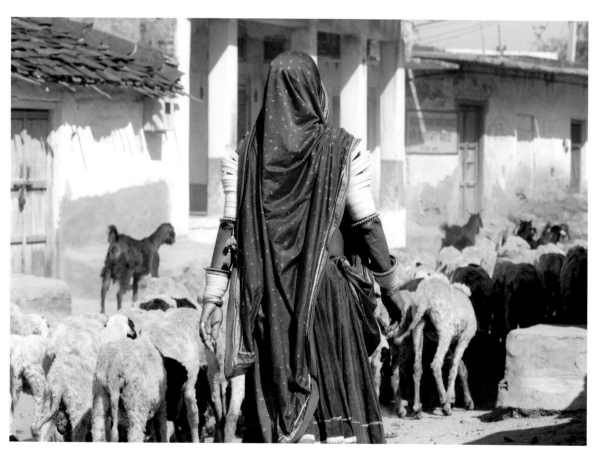

A shepherdess guides sheep and goats through a hamlet. Near Deogarh, Rajasthan.

GOLDEN TEMPLE, AMRITSAR

The Golden Temple at Amritsar remains inextricably linked with 1984, when then–prime minister Indira Gandhi ordered her troops to storm the complex, which had become a base for armed Sikh separatists; official figures put the subsequent death toll at 83 soldiers and nearly 500 civilians, but up to 2,000 pilgrims may also have died in the battle.

Within months, Indira Gandhi had been assassinated by her Sikh bodyguards, leading to the massacre of nearly 4,000 innocent Sikhs in Delhi riots. Not until 1998 did Sonia Gandhi (widow of Indira's son Rajiv Gandhi, who also served as prime minister and was assassinated) apologize for the attack, calling it a great mistake.

Such horrors are hard to reconcile with the impressive calm of today's restored Golden Temple, a community of worshippers with an ever-changing population, which welcomes all creeds. Thousands visit each day and are fed by teams of volunteers. To walk around the Temple, day or night, leaves a lasting impression of the depth and openness of the Sikh religion. ∎

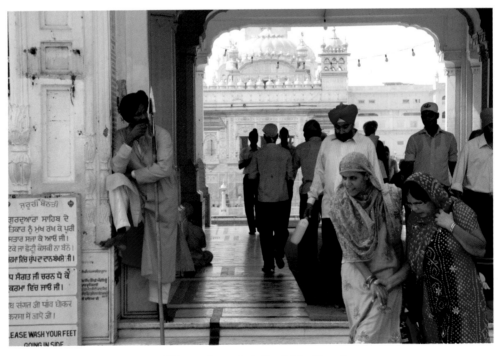

A Sikh guards a gate to the Golden Temple.
Amritsar, Punjab.

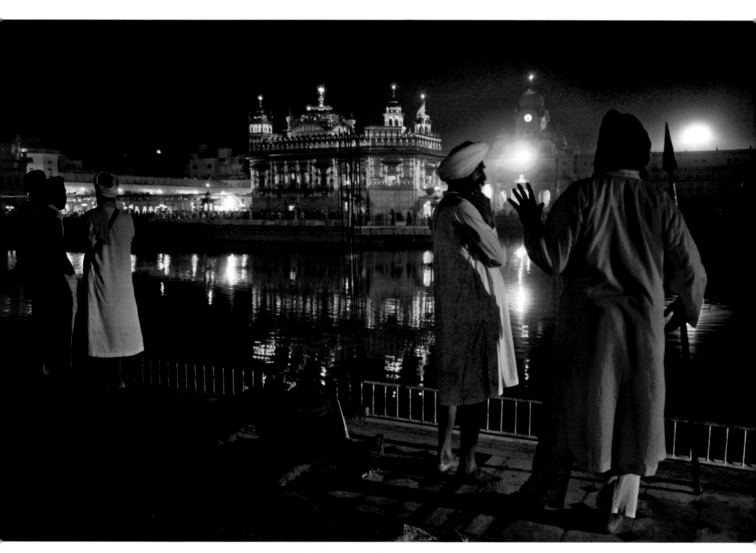

A Golden Temple night guard chats with a pilgrim.
Amritsar, Punjab.

83

GUJARAT EARTHQUAKE

On India's Republic Day in 2001, an earthquake measuring 7.9 on the Richter scale hit the state of Gujarat, its epicenter close to the city of Bhuj. The quake killed 20,000, injured up to 170,000, and destroyed a million properties (with a total cost of over $5 billion).

Yet how many Westerners are aware of this massive natural disaster, or at least its scope of destruction?
∎

The ornate facade is all that remains of a once-elegant village house. Near Bhuj, Gujarat.

HARIDWAR

H

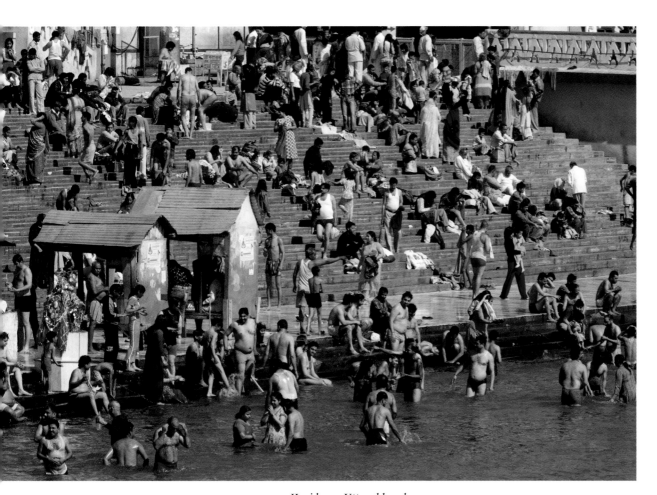

Haridwar, Uttarakhand.

As one of the four sites in Hindu mythology where the elixir of immortality was spilled, Haridwar has become a revered location. The town also has a more earthly appeal: since it is one of the first towns on the Ganges as the river leaves the mountains for the open plains, Haridwar offers the least polluted water for ritualistic bathing.　　■

HEALTH

Indian life expectancy has risen in the past thirty years from fifty to sixty-three, while the infant mortality rate has fallen by half. That's the good news. . . .

Of the 22 million Indians living with disabilities, 15 million are blind and 100,000 have leprosy. Each year nearly 2 million contract tuberculosis, and 2 million newborns die, with malnutrition (which costs the nation $10 billion a year) affecting nearly half of all children under the age of three.

The litany is endless, shameful, and incomprehensible in scale, yet the Indian government still allots only 1 percent of their GDP to health, promising an increase to a mere 2 percent by 2011. ■

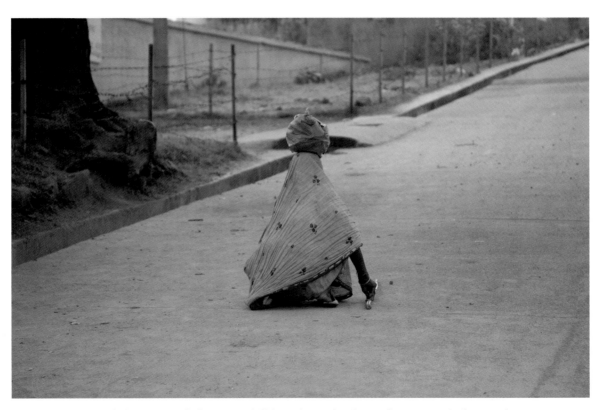

A crippled woman works her way uphill from the marketplace, a few tortuous inches at a time,
balancing a bag of vegetables on her head and carrying a stick in her right hand to protect her groceries
from thieves and feral dogs. Orchha, Madhya Pradesh.

HORSES

His was a face not to be missed, but he held his hand over my lens, mumbling softly; after 149 days in India, he was the first person to refuse to be photographed, and it came as something of a shock.

"He says he won't be photographed without his horse," said our guide, so we followed him to his house and waited in the courtyard before he appeared with a magnificent Marwari, descended from the warhorses bred by the ruling families in feudal India.

"Have you ever seen horses' ears like that, bending inward?" asked the guide. Indeed I had—they were the last things I saw before being knocked unconscious in Rajasthan two years earlier.

Invited to join a bird-watching party at a tented camp, I'd swung a 600mm on my back and mounted a Marwari with the confidence of one who had not ridden for sixty years. Though the guide had told us to keep strictly in line, the young American in front looked the sort of girl who'd want to hear my life story. As I drew abreast, my mount sunk its teeth into the neck of hers and began a bucking wrestle to the death. The next thing I remember was regaining consciousness on my back, with the guide gently turning my head for signs of spinal damage.

When he asked if it had put me off riding, I said I'd be happy to try again in another sixty years. ■

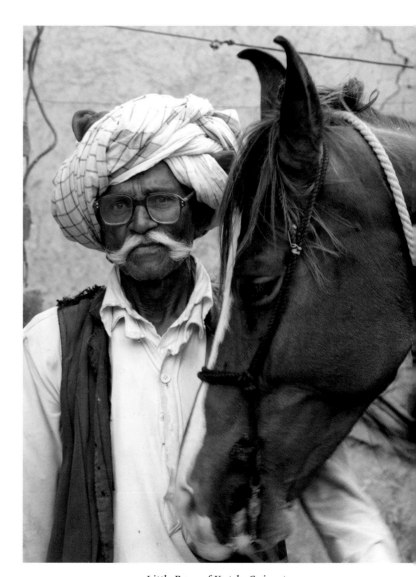

Little Rann of Kutch, Gujarat.

87

HYGIENE

How long the term "Indian hygiene" will remain an oxymoron is anyone's guess; such is the gulf between India's ingrained standards of hygiene and garbage disposal and those of the Western world. No aspect of India is so sorely in need of western-ization. Poor standards of hygiene, coupled with sluggish legislation and funding, lax health education, and the karma of acceptance, contribute to the deaths of half a million children each year. ∎

Paradoxically, Hindus view personal hygiene as a spiritual necessity; while public washing is ubiquitous, it is never practiced in the nude. Jhansi/Orchha road, Tamil Nadu.

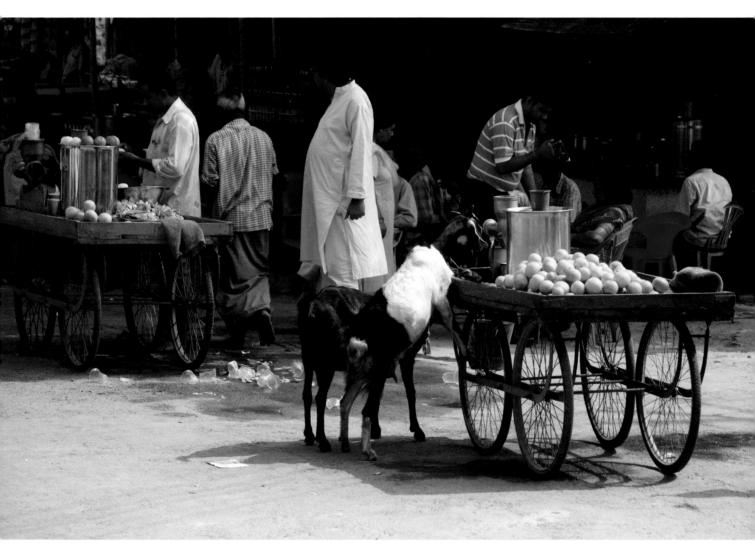

A goat takes advantage of an absent orange juice seller.
Varanasi, Uttar Pradesh.

IMPROVISATION

When a tire blows and you have no jack (which would probably cost your year's salary anyway), do what all Indians do and improvise, stacking a few bricks from your load so you can get the wheel off for repair and arranging others in a little circle to warn traffic.

But how do you lift your load to get the brick stack beneath the axle? Simple: you employ the audience of spare people who instantly materialize at such occasions to lift the load.

In the absence of authority, legislation, infrastructure, health and safety, or finances for the unexpected, the breadline Indian has developed the art of improvisation to the point that obsolescence, terminal damage, and wastage do not exist. ∎

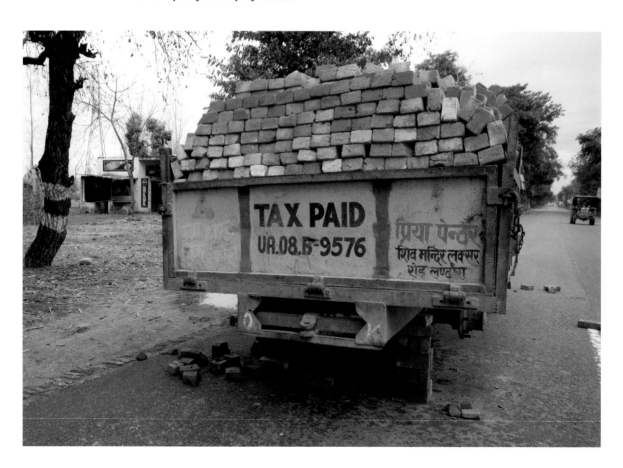

INDUSTRY

A few years ago it was China, but today it's India, as foreign politicians, CEOs, and investors land daily to talk business and industrial investment, giving support to the government's belief that foreign venture will exceed $30 billion in the coming years. Yet poor infrastructure, carbon-paper red tape, and political wrangling still make Indian industry a boom-or-bubble gamble. ∎

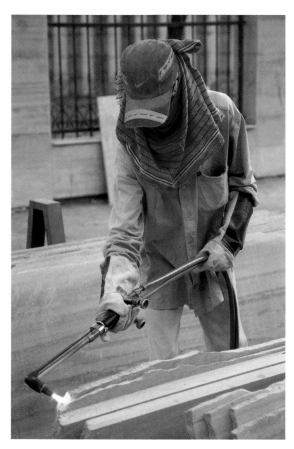

Surface "grain" patterns are burned onto plain marble. Madurai, Tamil Nadu.

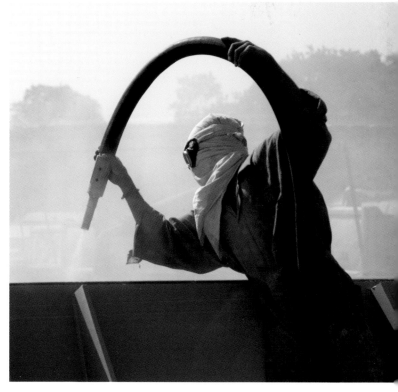

High-pressure water blasting at a construction site. Outside Mysore, Karnataka.

INFRASTRUCTURE

As long as India's infrastructure development was controlled by the public sector, creaking bureaucracy and corruption ensured a hopeless rate of progress.

By 2002 the government was still spending only 6 percent of its GDP on infrastructure, thus limiting the nation's pace of development, so they were forced to open up to the private sector and foreign money. Outside financing has helped, but the inherent corruption and red tape remain, and the plentiful, low-cost labor that might initially attract the foreign investor is counteracted by high-cost, low-quality transport and power services.

Official estimates of subsequent progress barely tally with the trickle-down reality, proving that no amount you can throw at the problem will change the Indian psyche overnight. ∎

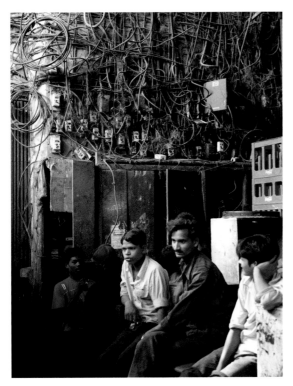

Itinerant labor waits beneath Crawford Market's main junction box. Mumbai.

Working telephone lines. Near Rishikesh, Uttarakhand.

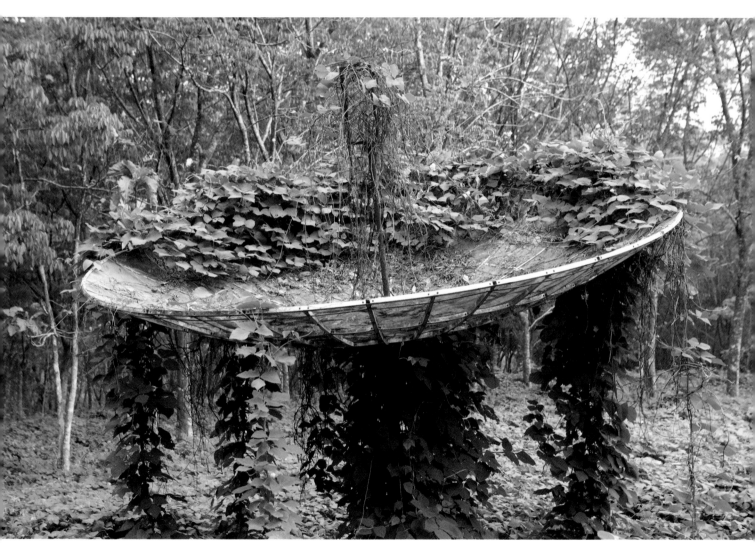

An abandoned satellite dish succumbs to vegetation.
Near Vazhoor, Kerala.

93

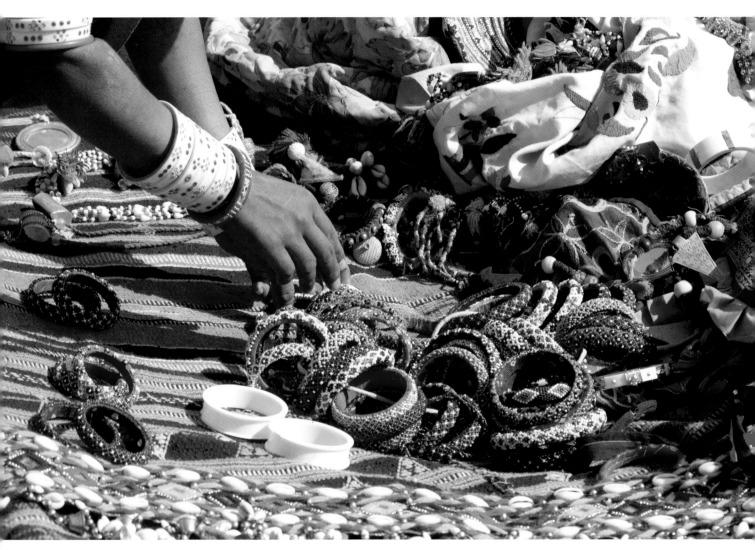

*Handmade bangles and beads on sale
in a Mir tribal village. Gujarat.*

JEWELRY

With jewelry being the first choice for wedding gifts and dowries, bling-loving India has become the world's largest consumer of gold, accounting for half the total mined.

India also produces 95 percent of the world's cut diamonds—the country's biggest export—in an industry that provides a livelihood for a million craftsmen (including thirty thousand child workers).

In Mumbai they say that every family should have an honest doctor, lawyer, and jeweler—not necessarily in that order. ∎

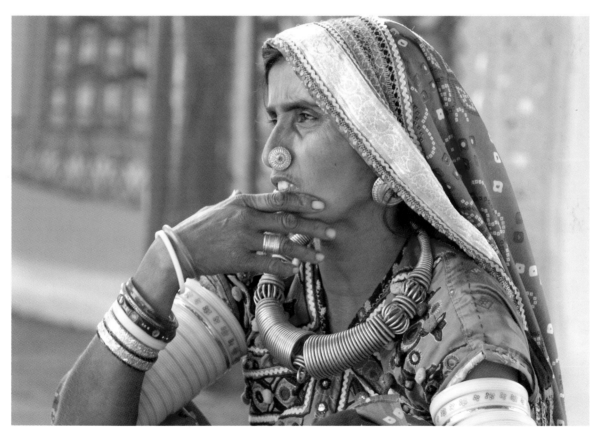

A woman in a Banni tribal village wears
gold and silver jewelry. Gujarat.

JUGAAD

For the three decades before the automobile manufacturer Tata unveiled its $2,500 Nano, the Jugaad was the one vehicle the rural poor could aspire to.

Basically a single-stroke water-pump engine on a chassis with four wheels, it is improvised out of necessity by village carpenters or mechanics from whatever is available and costs $600 and up. Top-end Jugaads might feature a tractor engine, but most are devoid of electrics, a roof, and reliable brakes. Jugaads barely break 20 mph.

Officially they don't exist, as the Jugaad cannot be insured, registered, or taxed, and most drivers lack a license. Officially, they should be confiscated under the Motor Vehicles Act, but despite the Nano's release, Jugaads will remain the transport of choice for the poor for years to come.

This being India, the Jugaad's passenger capacity is practically infinite, with a dozen to twenty riders considered a normal load. This transport is thus cheaper than a donkey and marginally faster. One Jugaad driver we met had just completed a twelve-mile journey, charging each passenger 17 cents for the trip. Let the Nano beat that. ∎

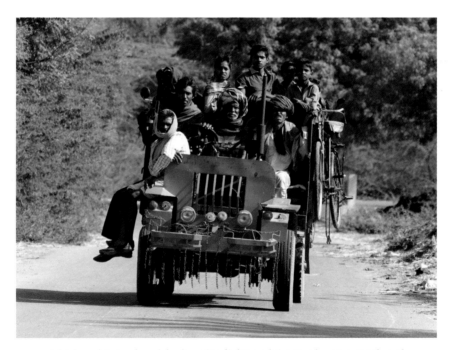

A high-end Jugaad model—boasting lights and tire tread—on a rural road.
We counted over twenty passengers as it passed. Shahpura, Rajasthan.

KARMA

Karma (noun). Hinduism and Buddhism. The total effect of a person's actions and conduct during the successive phases of the person's existence, regarded as determining the person's destiny.

—*The American Heritage Dictionary*

The American Heritage Dictionary's definition of karma is only one of a hundred interpretations, which can confuse the reader and dilute the power of the ideology. Karma is best understood by witnessing the way Hindus handle experiences, both good and bad, with a spiritual acceptance beyond the ability of much of the Western world.

Coupled with an ingrained caste system, such fatalism might well keep the lid on reactionary forces against the nation's massive social divide. ■

Huddled in an open four-by-four waiting impatiently for the Bandhavgarh Reserve gates to open at dawn, we saw a hunched farmer appear from the darkness and guide his four cows through a stream. His matchstick legs struggling in the icy water, the farmer was armed with a blanket to defend against the freezing night and a bamboo-handled hatchet to protect his quartet from nocturnal predators.

He wandered over and stared at us in silence: ours was a new camp in the area, and we Europeans might have been Martians to him as he took in our six-layered clothing, cameras, hot-water bottles, and picnic goodies.

"His name is Jagdish," said the warden. I took his picture, and he gave a thin smile.

Back in camp that evening, we were told that while we'd been crisscrossing the reserve in a vain search for more tigers, a couple of them had taken down two of his cows on common ground (thus qualifying him for government compensation), but then dragged the bodies fifty yards over a boundary ditch into the game reserve (for which there was no compensation).

The painful irony of bureaucracy robbing him of half his herd and livelihood triggered my compassion, and I offered to start a collection to replace the cows. Locals shrugged and said that Jagdish would view it as karma, a fatalism that we in our litigious, compensatory world might never truly grasp.

When the feeling of guilt occasionally returns that we did nothing to help, I take comfort in the thought that he's probably more content in life than we are. ◀

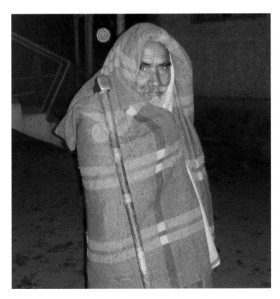

Bandhavgarh, Madhya Pradesh.

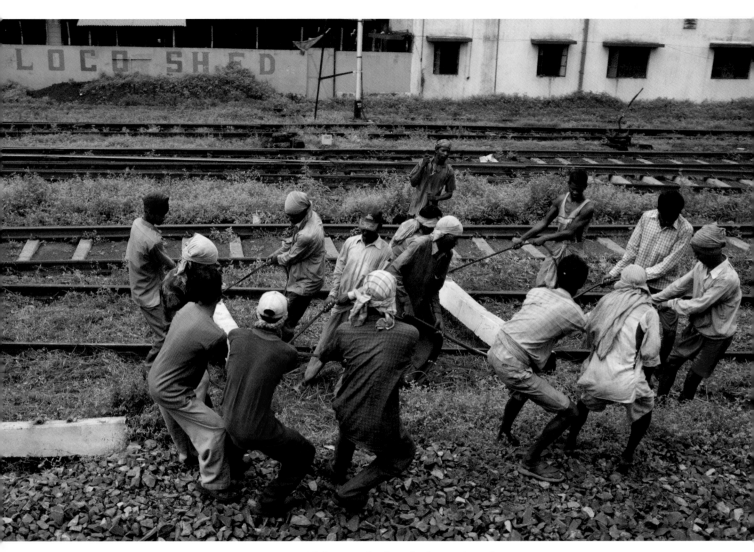

A labor gang hauls train sleepers into place.
Calcutta.

LABOR

Successive Indian governments have contrived to mismanage a half-billion-person labor pool on dirt-poor wages by creating a Byzantine web of intransigent labor laws that spawn costly, dead-end disputes (533,000 were pending in Indian labor courts in 2000, nearly 29,000 of which were over ten years old).

The ingrained job-for-life mentality—which is understandable when regular employment is often a matter of life or death—has to be softened with more flexible labor laws and bolstered safety nets for the unemployed if India is to become a true global player. ∎

L

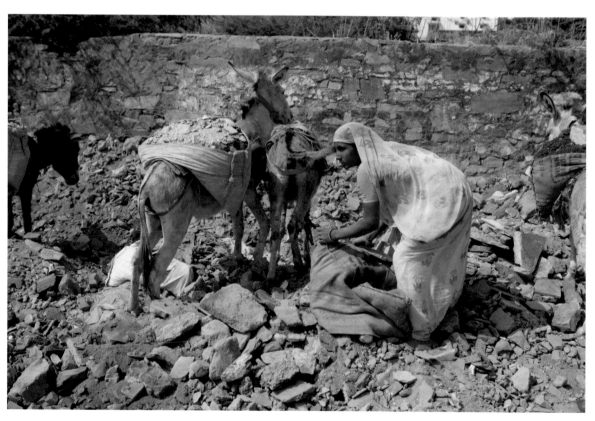

A woman loads panniered donkeys with rubble
for roadwork. Near Udaipur, Rajasthan.

LAW

While India's high courts and Supreme Court have a backlog of 3.5 million cases, the lower courts' backlog approaches 22 million, with a million more added to the arrears each year.

With only thirteen judges for every million Indians, theoretical clearing of India's judicial backlog would take over 120 years.

Though the Indian judiciary might accuse the British Raj of initiating such bureaucratic madness, sixty years seems ample time for India to have made moderate judiciary progress—yet much of the true cause lies in the way the tight-knit judiciary profession manipulates the system, excluding competent lower castes. ■

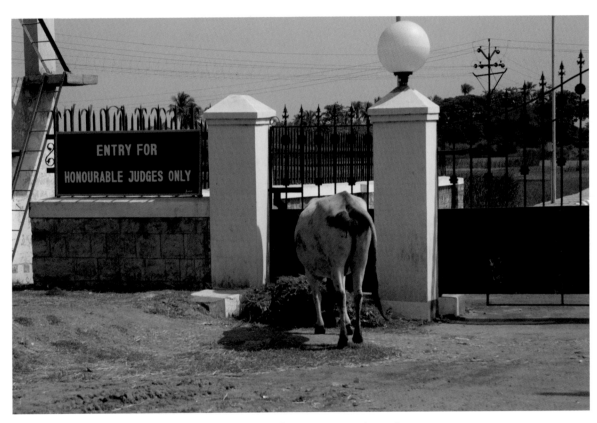

The Honourable Judges' entrance to the Madras High Court's bench. Madurai, Tamil Nadu.

MANURE

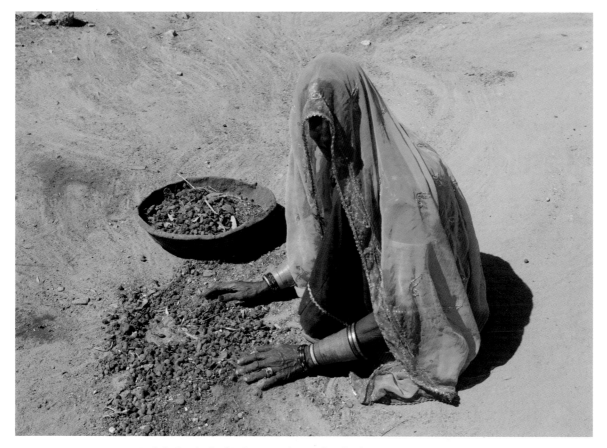
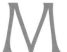

Such is the vital role of manure in rural India that even goat pellets are assiduously swept up for fuel or heating. Nimaj, Rajasthan.

Three-quarters of India's cow manure is burned for cooking and heating, a tradition that depletes soil fertility, while the smoke causes grave health problems in unventilated village huts. The government drive to use biogas units that can extract fuel from manure before using the remaining solids as organic fertilizer is so underfunded and underpromoted that these wasteful rural practices are unlikely to be stemmed in the near future. ∎

MARKETS

Market trading is available to anyone with produce, a pair of scales, and the ability to sit cross-legged, while the absence of price tags provides the opportunity to charge different prices to regulars, friends, lovers, gurus, strangers, village elders, and police.

With lack of refrigeration limiting produce shelf life, stock is constantly rearranged to give the impression of freshness and abundance. At the end of the day, all usable remains are taken home for family consumption, while the debris is left for cows and goats. ∎

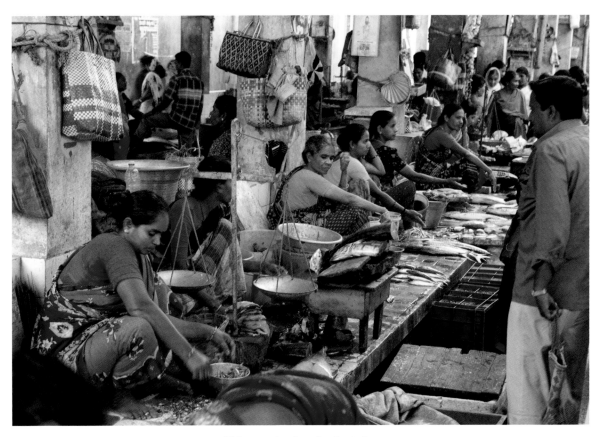

Fishermen's wives dominate the
Pondicherry fish market.

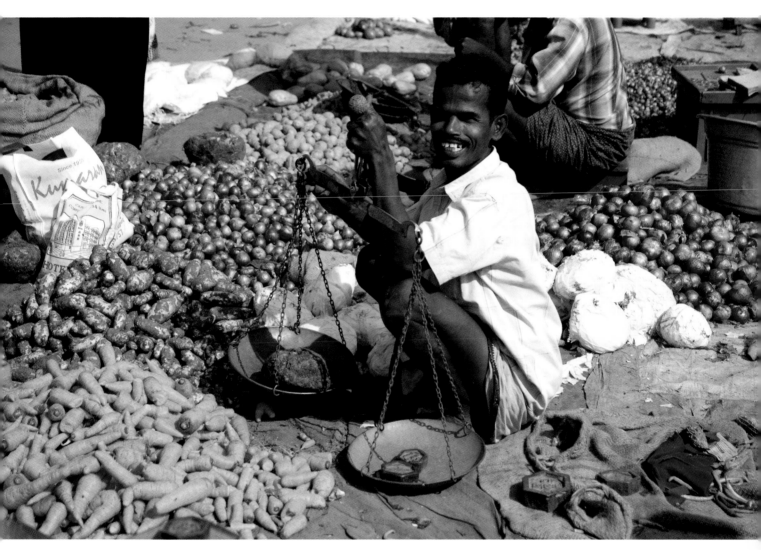

A market trader with crude scales.
Near Tanjore, Tamil Nadu.

MODERN INDIA

*Known as India's Silicon Valley, Bangalore provides one-third of the nation's
IT exports, is home to 10,000 millionaires, and was voted by CNN as the world's
best place to do business. Yet here, outside an IT park, anachronistic auto-rickshaws
still line up for work, the only way to negotiate stifling traffic jams caused
by a road system that has failed dismally to match the city's
phenomenal growth. Bangalore, Karnataka.*

While China has undergone an industrial revolution, India's economic boom has been achieved with a dynamic technology sector and a mass of service businesses.

More remarkably, it has been achieved despite ponderous bureaucracy and inadequate infrastructure, barely tapping the low-wage labor pool, which is limited by caste and social inequality. What India could achieve if these restrictions were lifted is hard to imagine.

With less than forty elite families having a combined wealth of $190 billion (or a quarter of the nation's GDP), an exploding middle class already matching the population of the United States, and a million engineering graduates produced each year, the majority of Indians might be entitled to ask, "What boom?" 600 million of them are still without access to electricity, and 300 million are uncertain where their next meal is coming from.

While financial statistics might support the "tiger economy" tag, the phrase "Modern India" can hardly be used when measuring the growth in moral terms. ∎

For the poor, such as this pilgrim, India's modernization
offers little. Trichy Temple Complex, Tamil Nadu.

MONSOON

Despite a billion prayers to a thousand gods, Indians are hopelessly vulnerable to the capricious rain-laden monsoon wind that spreads from the southwest each June to September, both lifesaving and life-taking on a scale unimaginable to the rest of the world.

A few days early, or a few days late, and this double-headed monster's thirty-five inches of rainfall can bring salvation to the 700,000,000 people dependent on agriculture, or kill thousands with drought and flooding while wrecking the economy. The monsoon's awesome power is magnified by the lack of infrastructure to store the rain, irrigation to protect the farmers, or a drainage system capable of protecting city dwellers.

With global warming expected to bring more eccentric patterns as summers grow hotter and rains fiercer, sufficient government containment seems a remote dream. ∎

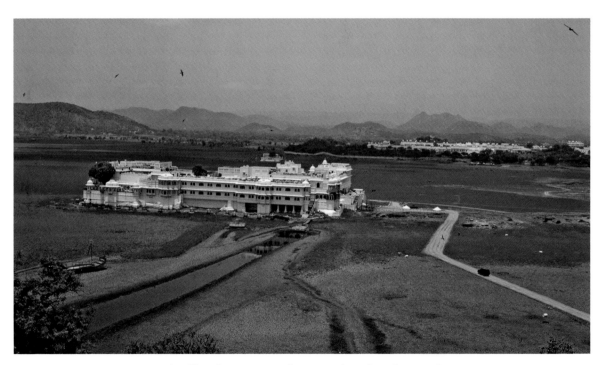

The effect of monsoons can be seen at the Lake Palace Hotel,
which lies in the dried bed of Lake Pichola part of the year. . .
Photograph by Namit Arora (shunya.net).

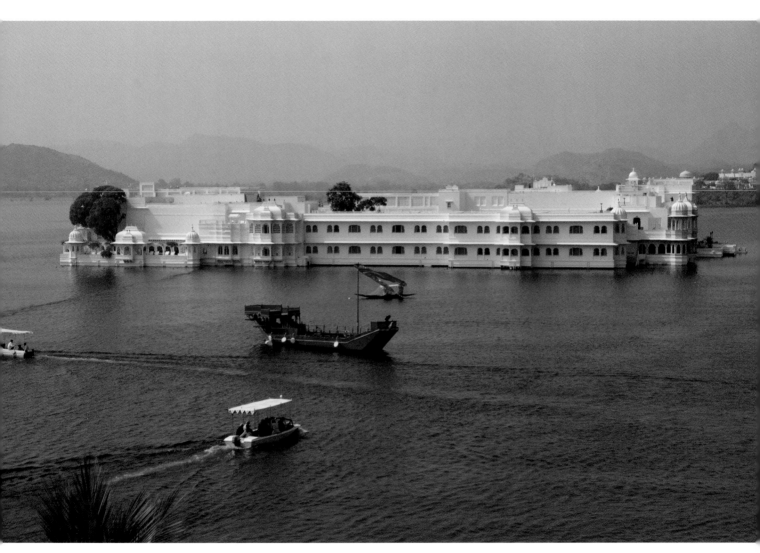

*. . .Yet, after the monsoon rains, it becomes an island, and guests
must be ferried to the hotel. Udaipur, Rajasthan.*

107

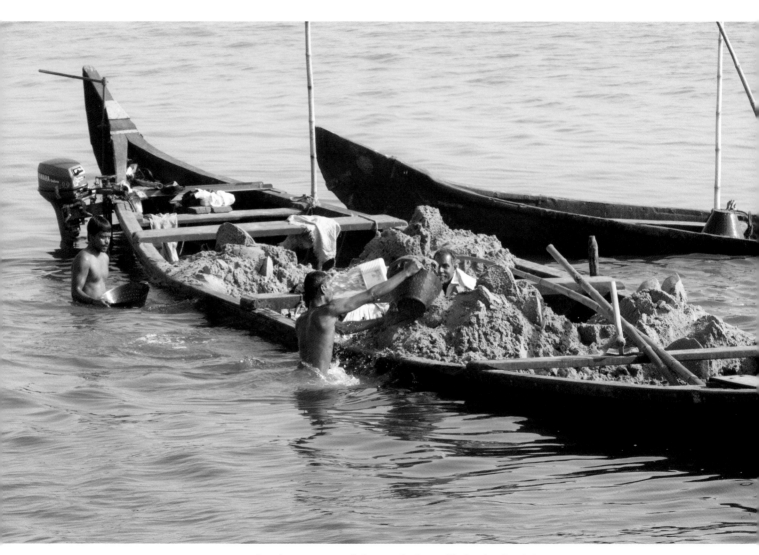

Mud-gatherers use metal sieves to drain mud before loading it in canoes.
Alleppey, Kerala.

MUD-GATHERING

Cruising the Keralan backwaters, I asked our rice barge waiter how he got the unusual name of Godwin.

"My father chose it," he said. "Godwin was the Earl of Wessex in the eleventh century, and his son became the king of England."

Chastened by my ignorance, I suggested that his father must have been a well-read man.

"Yes," said Godwin, "my father was secretary to a religious order in West Bengal—a very good position. But when he moved the family south to Kerala, the only work he could get was a night shift diving to the bottom of the lakes to scoop mud up with his bare hands and dump it in a dugout canoe to be used in construction.

He's been doing it now for forty-seven years, but it's terrible work and dangerous—there are no lights to work by, and holding your breath while digging is so exhausting. At the end of an eight-hour shift he gets about five dollars."

It had been a joy of a day, photographing diving birds and passing village life, but this story so dampened my spirits that it was some time before I ventured to ask why his father moved south to Kerala in the first place.

"He had to," said Godwin, "for the sake of his health." ∎

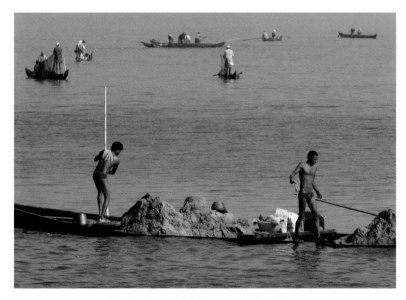

Precariously close to sinking, two mud-gatherers punt through fishermen to unload. Alleppey, Kerala.

MUMBAI

Those eager to see India in extreme, while keeping their visit short, ought to head straight to Mumbai, formerly known as Bombay.

From a former fishing village, Mumbai has grown to become a metropolitan bubble about to burst, physically and logistically unable to cope with an official population nearing 20 million (some put it at 24 million, which, given the current rate of urban migration, may be nearer the mark by the time you finish this book).

Mumbai is where most Indian millionaires live. Here Mukesh Ambani has a twenty-seven-story home kept by a staff of 600 (consolation for being only the second-richest man in India). Meanwhile, a million people live in Dharavi, Asia's biggest slum (there are tours, if you feel so inclined), and half of Mumbai's citizens are without electricity or running water (two million have no access to toilets).

One day may be enough. ∎

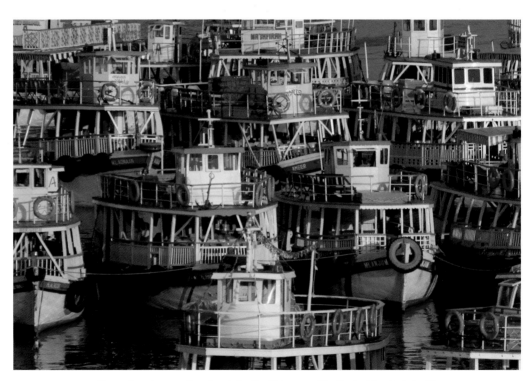

Dawn breaks over ferryboats by the Gateway of India in Mumbai, built
to commemorate the 1911 visit by King George V and Queen Mary.

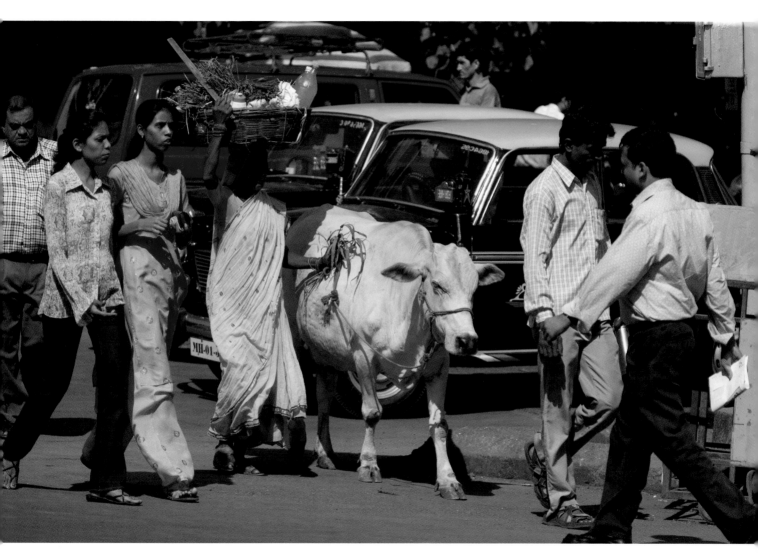

Mixed traffic passes the
Old Opera House in Mumbai.

111

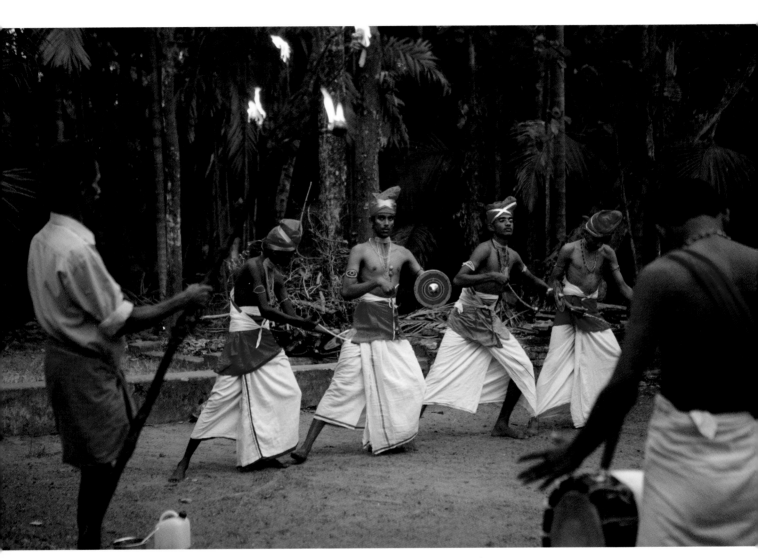

*Illuminated by coconut-oil torches, young men perform a Velakali dance,
originally a form of military recruitment. Ambalapuzha, Kerala.*

MUSIC & DANCE

While traditional music and dance survives, equal in diversity to that of Indian cultures, the ubiquitous village bands are a more common sight, called upon for weddings, functions, or any excuse for celebration.

The quality ranges from a couple of amateur musicians, whose output is drowned by cymbals or drums, to the top-rupee band, which invariably centers around amplified loudspeakers on a wheeled cart.

On occasions, there is a culture crossover when such musicians are called upon to supply "authentic" music and dance for visitors. While we were in Shahpura, our hostess, a maharajah's daughter, apologized for the musicians' tardiness but knew they were on their way as they had called from their cell phones, now ubiquitously used by such musicians.

What she didn't know was the group had gotten hammered at a previous wedding engagement, and soon our seated sextet had broken into drunken, swaying chant, while the dervish dancer climbed a mango tree and hung in shaking limbo until the branch broke. Despite a heavy fall, he continued his spinning leaps while trying to re-braid his turban. Then he grabbed a ceremonial staff and began swinging it closer and closer in menacing arcs, as the music reached a crescendo. Our hostess, watching with growing alarm, finally shouted to me, "I fear I shall have to phone them to stop." ■

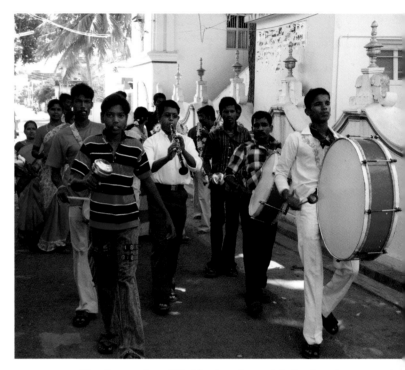

The absence of amplified loudspeakers might be viewed as a plus for the audience of this budget band, marching to a wedding. Kanadukathan, Tamil Nadu.

NEWSPAPERS

N

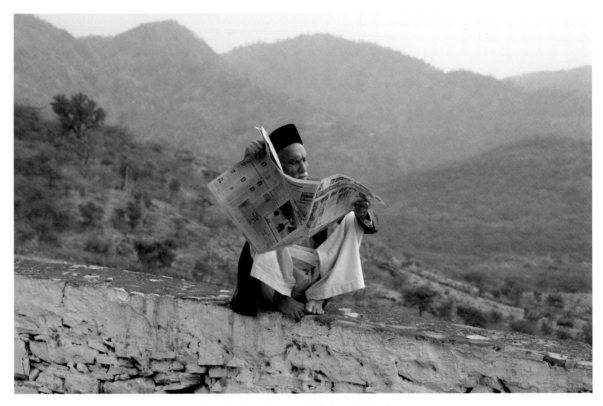

A roadside reader near Udaipur, Rajasthan.

Bucking the trend of the Western world, Indian newspapers are booming; as the national literacy rate reaches 60 percent, newspaper publishers are chasing a growing market of over 600 million readers. With the industry soon to be worth around $5 billion and growing by 15 percent annually, foreign investors are circling; they see the greatest potential in untapped vernacular papers in a market so vast that the *Times of India*—with the largest English-reading circulation in the world—doesn't even make the top five sellers amongst India's two-hundred-odd newspapers.

Compared with the tightly regulated American press, Indian journalism can verge on the anarchistic, with hacks called upon to write readers' letters, fill in horoscope columns when the contracted astrologer is on vacation, and so on. Even wholly invented interviews rarely result in dismissal. ■

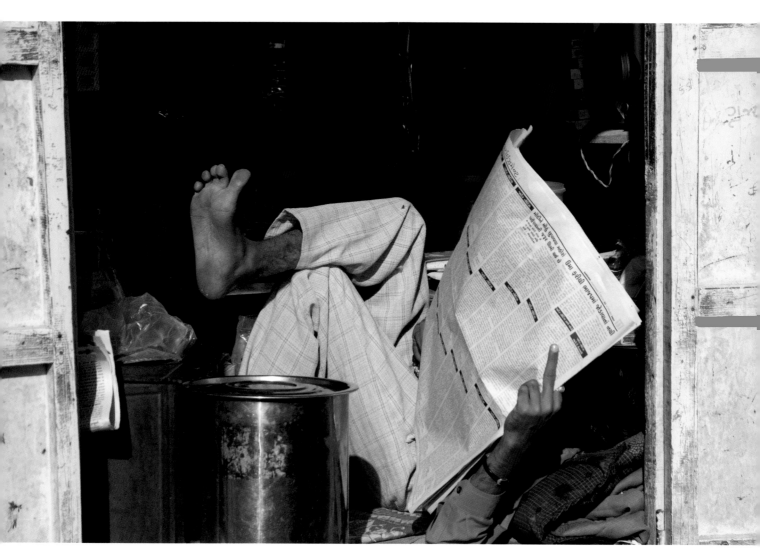

*A villager catches up on the news before opening
his stall. Little Rann of Kutch, Gujarat.*

NOMADS

Though around 7 percent of the Indian population is nomadic, not until 2006 did an Indian government commission to develop their communities offer them some form of recognition.

Historically misunderstood and ill treated, nomads cling to a lifestyle distant from every facet of modern India, keeping only possessions that will fit on the back of a donkey—tents, poles, and firewood, as well as goats, chickens, and dogs. ■

A family of nomads on the move
near Desuri, Rajasthan.

ONIONS

In America, it's oil; in Russia, it's potatoes; in India, it's onions.

As a vital ingredient in Indian cuisine, the humble onion is also expected by the populace to be the cheapest, so when onion market prices rise, politicians beware—the Onion Factor can make or break them. Anger over rising onion prices boosted Indira Gandhi's rise to power in 1980, and nine years later it was onion prices again that helped the Hindu nationalist party win support in the national elections. ∎

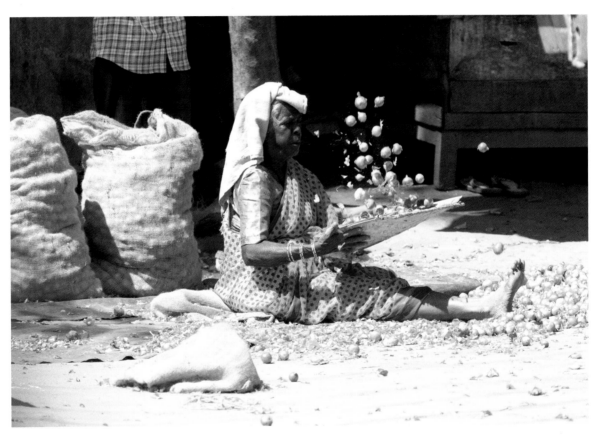

An old woman winnows small onions by the roadside. Tanjore, Tamil Nadu.

OPIUM

In a bid to control the traditional production of opium, the Central Narcotics Bureau licenses farmers in northern India to grow the crop on one-tenth of an acre on condition they produce at least ten pounds per annum for government exports to the pharmaceutical industry—though the pittance they pay the farmer would make a New York dealer's jaw drop.

In reality, an unknown percentage—the CIA once put it at around 5,000 acres' worth—reaches the black market or is consumed by locals, who have traditionally used it either as a cure-all or a who-cares-if-it-doesn't. ∎

An elder waits his turn to sip an opium solution at an elder's ceremony in a Bishnoi tribal village. (When our turn came, I felt that the opium was too weak to have any effect, but my wife woke in the night realizing she'd tipped the elder with a 500-rupee note instead of the intended 50 rupees, so maybe it wasn't.) Rohet, Rajasthan.

OVERLOAD

Here in the Land of Overload, legislation and health and safety are dialects unknown to 90 percent of the population—and the remainder break the rules anyway. Here individuals triumph over authority, need creates improvisation, and overloading becomes a necessary way of life, even of survival.

It's anarchy, it's madness, and it works. ■

Bicycles

A brief tea stop on a Jaipur street corner in Rajasthan turned into an open-ended vigil with a vow to photograph the most overloaded bicycle in India.

The burdened cyclists struggled past, loaded down with tires, textiles, schoolkids, goats, beds, palm fronds, wooden beds, and a four-foot stack of fresh eggs. Then, after an hour on watch, came a man in his sixties pumping a gearless bike at a slow walking pace, half hidden by a load of nine giant water tanks. It was so ludicrous it made you laugh aloud, but no one else gave him a second glance. Jaipur, Rajasthan. ▶

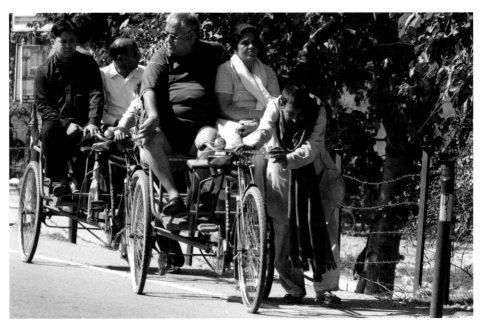

It's the luck of the draw at the Haridwar rickshaw rank. What you expect is a quiet Sunday ferrying stick-thin pilgrims to bathe in the Ganges, and what you get is the largest man in the state of Uttarakhand and his wife, who want to go up the hill leading north out of town.

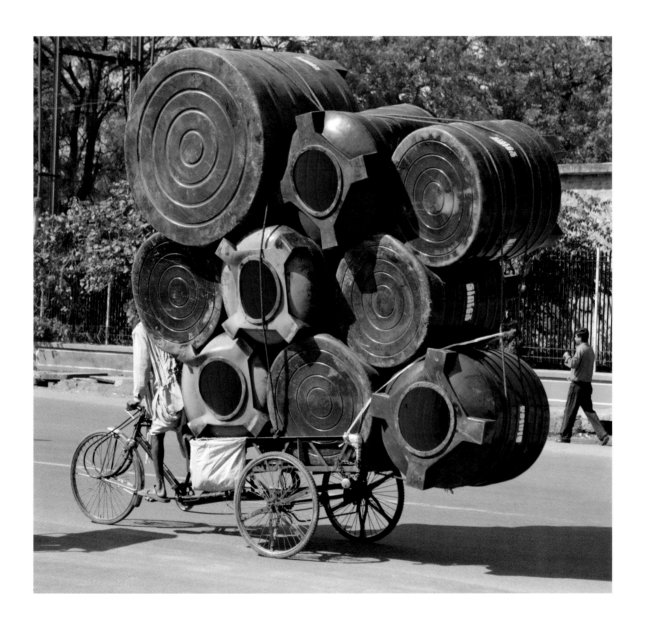

Head

India's cheapest form of freight reaches its peak of ingenuity at Calcutta's indoor night market, a seething mass of produce and people. With space at such a premium, progress can only be made by hopping from plate-sized patches of mulched waste, ducking and diving between oncoming porters' loaded heads, and grabbing any available shoulder in a bid to remain upright. It is a Breughel vision of hell—and yet, like most of India, it works.

Outside, a lorry dumps sacks of sorghum weighing 1,200 pounds, and immediately a dozen men encircle the first sack, heaving against it like a circular rugby scrum, chanting in unison as they raise it six inches at a time until, at knee level, it defeats them.

For a minute, chests heaving, they regroup before trying again. This time, as it reaches chest height, six fresh porters dive beneath, take the weight with their heads, and began a synchronized, staggering walk into the market hall. I went to follow, but a foreman held a hand to my chest and said, "Bad time."

Bad time indeed, as somehow they had to get their load, weighing little less than a Tata Nano budget car, through the market mayhem by stepping only on those slimy black patches between produce and humanity, all the while avoiding the loaded heads of oncoming traffic.

For every load, each man earns three cents. ■

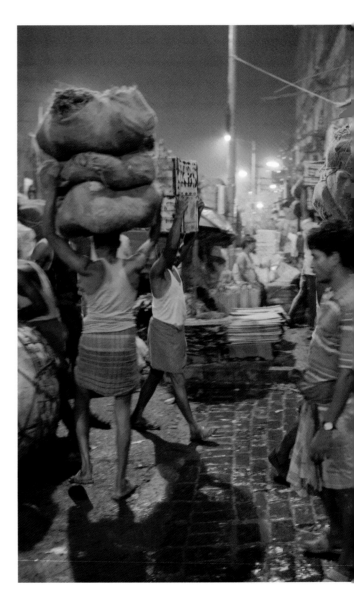

Night market, Calcutta.

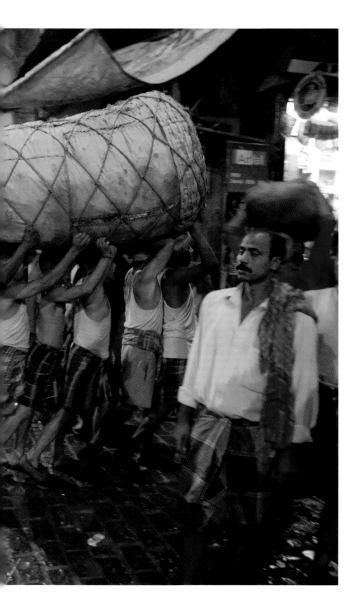

Motorcyle

Motorcycles remain a luxury for most and must accommodate families as they grow—any sighting of one ridden solo should be reported, as it's probably being stolen. ■

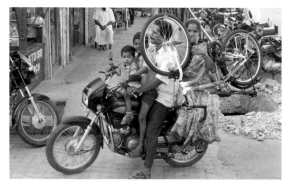

A motorcyclist totes his wife, their two children, and the family's new bicycle. Pondicherry.

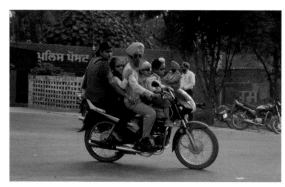

A Sikh family of five rides a Hero Honda (which represents around 50 percent of the Indian motorcycle market). Amritsar, Punjab.

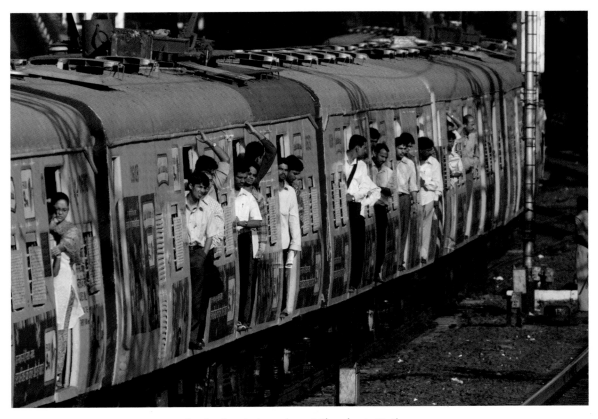

A suburban train arrives at Churchgate Station;
at mid-morning, it is relatively empty. Mumbai.

Trains

Carrying over six million commuters every day, it is understandable that Mumbai's urban railway system has the world's highest passenger density.

What is less understandable, perhaps even unimaginable, is the statistic that the subsequent peak-hours overcrowding creates a density figure of 14 to 16 passengers per square meter, classified by the formidable title of Super-Dense Crush Load.

If that figure seems physically impossible, remember that it includes all those riding the buffers between cars, sitting on the roof, and clinging to the outside of the cars, perhaps explaining the 3,500 deaths that occur anually on the suburban tracks. ∎

OVERLOAD

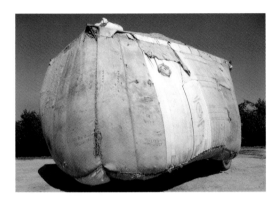

Trucks

This is a truck, recognizable by the wheel barely visible at bottom right. It's probably a front wheel, but nothing is certain, since this is in Rajasthan, Overload Center of the Land of Overload.

Here, trucks like this one, parked by a café near Tonk, are overloaded with grain chaff for animal feed. Then giant pouches of sewn-together sacks are slung over the sides, and these are also over-loaded, creating a giant muffin with a don't-ask center of gravity. The entire vehicle, which has a width double that of the chassis, now has to be driven down the middle of narrow, tree-lined roads. ◀

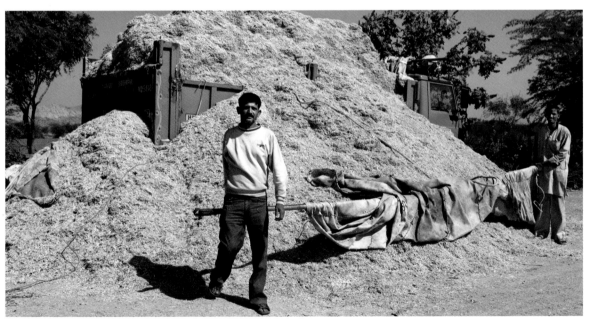

All it takes is weak stitching, a low branch, a pothole, a mild swerve, or a brush against another vehicle, and . . . Disaster.
Embarrassed at photographing the driver's misery, I mumbled, "Thank you." This being India, however,
he shook his head, smiled, and said, "Thank you," pleased to have been photographed. Near Tonk, Rajasthan.

125

PACE

P A first impression of India might be of many spare people waiting around for something to happen. That might also be the last impression, as there are times when the pace in the subcontinent can drop to a gear so unknown to the West it becomes therapeutic to watch. ∎

A woman cyclist is advised to ease up.
Pondicherry.

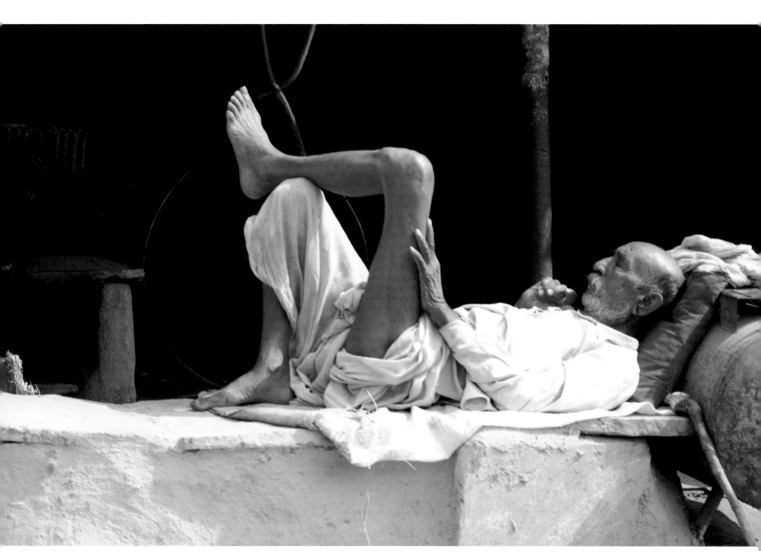

A villager catches up on quality time.
Near Ajadpura, Madhya Pradesh.

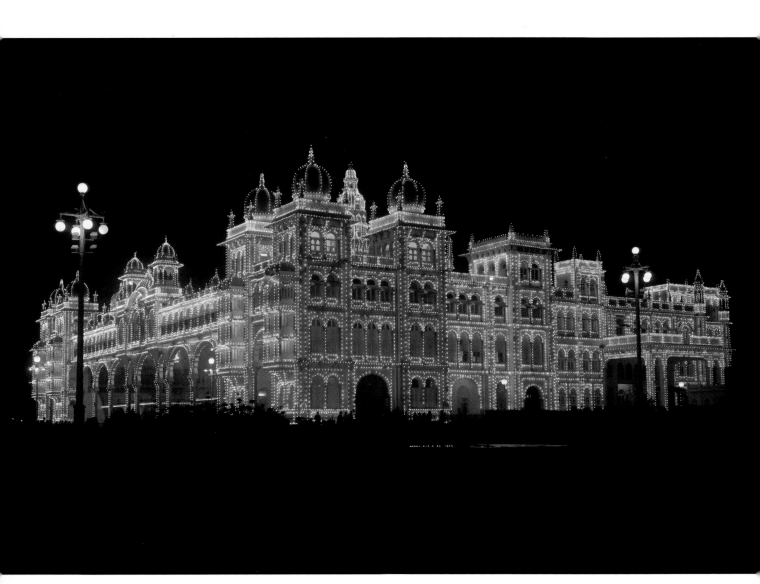

Mysore, Karnataka.

PALACES, FORTS—AND RESTORATION

The majority of palaces and forts—unless blessed with iconic status, hotel conversion, or the accolade of a UNESCO World Heritage Site (India has twenty-eight to date)—are woefully underfunded. Further hindering their efforts to be restored to their former glory are the usual problems of corruption, poor infrastructure, and bureaucratic delays.

While the dog-eared and decrepit condition of many landmark buildings might lend them a little mystique in the visitor's eyes, it can only accelerate the demise of these national treasures. ∎

Although the Palace of Mysore is illuminated only two hours every Sunday night and occasionally for festivals, Greenpeace has calculated that switching its 96,000 incandescent lightbulbs to compact fluorescent lamps would save over $100,000 a year. Mysore, Karnataka. ▶

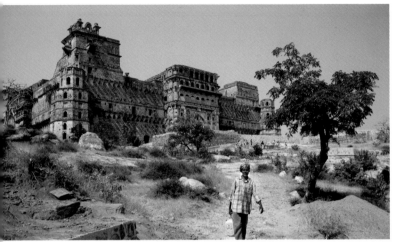

Garkhundhar Fort, near Orchha, Tamil Nadu.

The remote Garkhundhar Fort has no road access, so all water required for the eighty-strong restoration team must be brought up the last half-mile by hand. The two volunteer guides showing us round the twenty-five-acre fort were in the process of revealing that we were only the seventh and eighth visitors in seven months when the ninth, tenth, and eleventh burst in. Sometimes nothing happens all month, and then *wham!*, suddenly you need crowd control. ∎

A workman carries mortar past decorative elephants during restoration work in the Nayak Palace. Tanjore, Tamil Nadu.

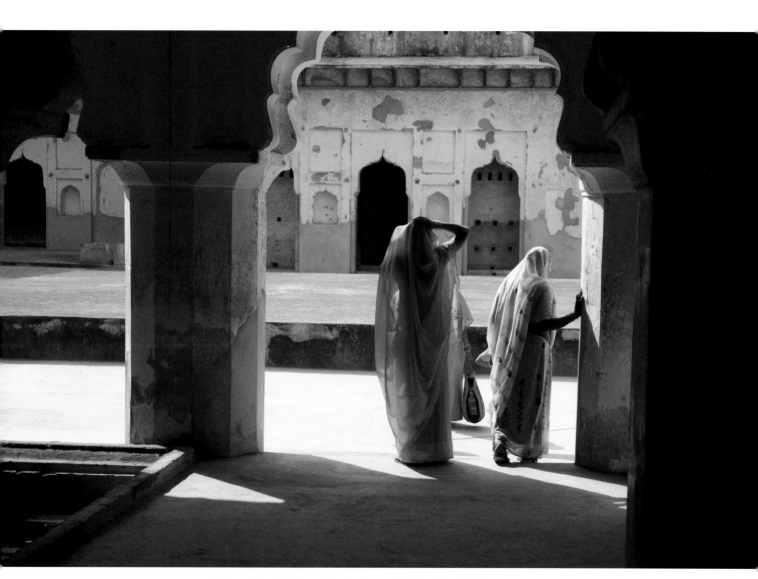

Visitors at the Garkhundhar Fort, near Orchha, Tamil Nadu.

PILGRIMS

However remote the road, they're always there—a little line that looks from a distance like workers making for the fields, but as you get closer, you see a limp flag or sash on a stick and realize they're pilgrims. They may be going half a mile to a village, twenty miles to a temple, or a hundred miles to a holy city; they may be giving thanks for a birth, a marriage, or a good crop; they may be going to pray for the deceased, honor the past, or hope for a blessed future. A few will be pushing invalids, some even carrying them, but each and every one will be seeking comfort from their own particular gods. ∎

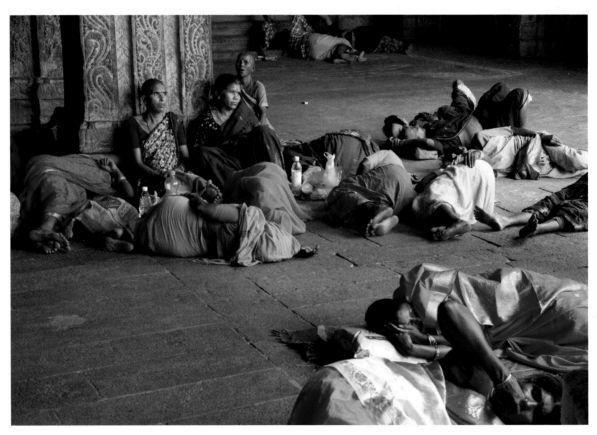

Exhausted pilgrims rest after arriving at the Srirangam Temple complex.
Trichy, Tamil Nadu.

132

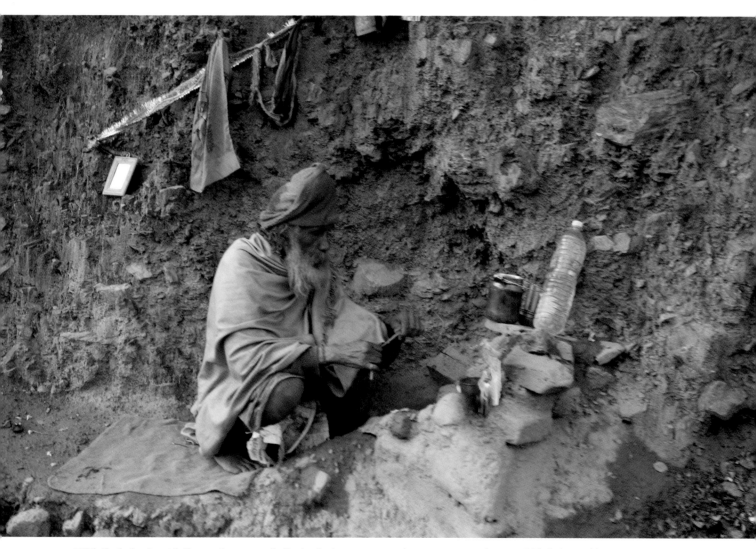

With the holy city at full capacity, an aged pilgrim finds a temporary home on a precarious roadside ledge and brews tea amid the choking fumes of trucks climbing the Dehradun road. Rishikesh, Uttarakhand.

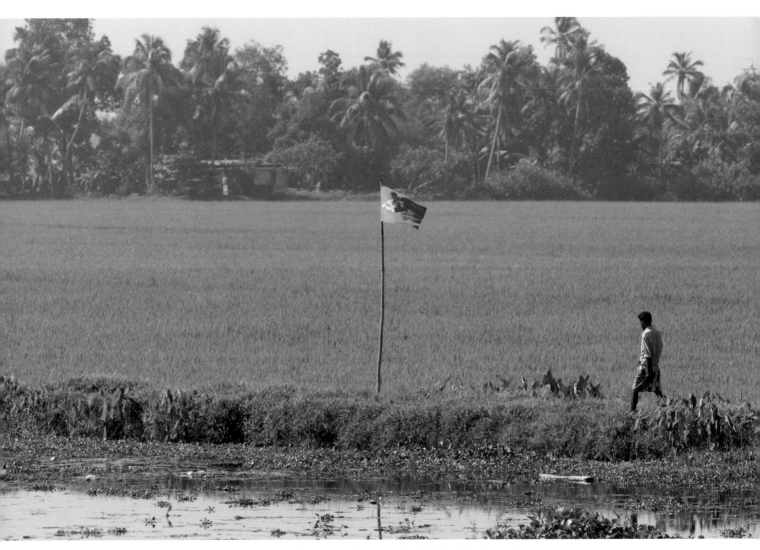

The Communist Party of India flag flies in Kerala,
home to its main support base. Alleppey, Kerala.

POLITICS

When Rupert Murdoch came to India in a bid to launch cable and satellite ventures, he convened with all major government ministers in New Delhi. Near the end of his visit, Murdoch talked with Dhirubhai Ambani, boss of the giant Reliance Industries, who asked who he had met so far. When Murdoch ran through the impressive list, Ambani said, "Ah, you've met all the right people, but if you want to get anywhere in India you've got to meet all the wrong people." ∎

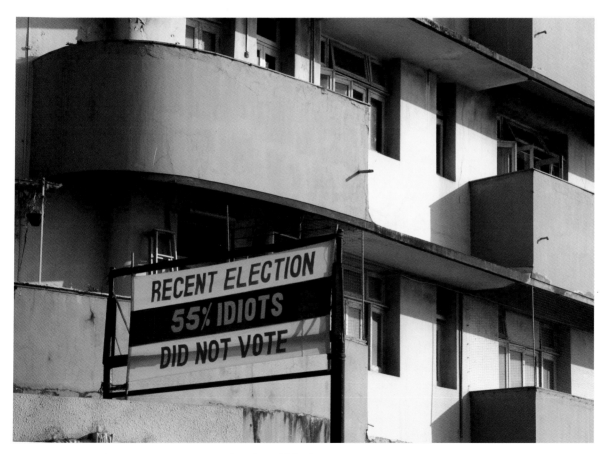

An admonishing banner appears
after local elections. Mumbai.

Propeled By Claen Fuel

Propelld By Clean Fuel

Propelle By Clean Fuel

Propelled By Clen Fuel

Propjjed by Clean Fvel

POLLUTION

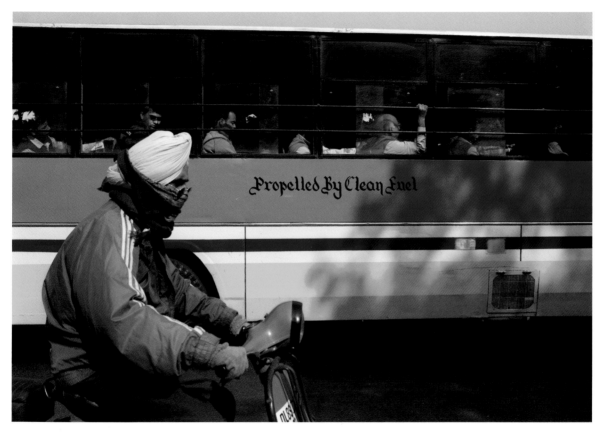

*The problem for Delhi Transport Corporation in spreading the news that their buses
have been converted to run on cleaner fuel is that even when their sign writer finally gets
the spelling right, some people still won't believe the message.*

Among India's huge welter of pollution problems—created by legislation inadequate to cope with the country's burgeoning industry and urbanization—is the growing and problematic issue of environmental degradation. A Delhi School of Economics professor estimates that factoring in pollution's environmental damage, India's flaunted annual economic growth of around 9 percent would have to be halved. Perhaps the tiger economy is not quite the creature imagined. ∎

POPULATION

India's population, at 1.136 billion people one-sixth of the world's total, is expected to overtake China's by 2050. (And this is despite the birth rate having fallen by half in the past thirty years to about three children per woman.) India still has a ways to go to reach the target replacement-level rate of 2.1 per woman.

India's population is still increasing at the rate of nearly sixteen million a year—one every two seconds. Put another way, the population will have increased by ten more Indians by the time you finish reading this paragraph. The government's birth control policies have been voluntary since the 1950s, except in 1975, when Indira Gandhi's government, declaring a state of emergency and faced with what was then a population of 620 million, attempted "voluntary" sterilization of the poor. This policy particularly alienated rural voters, who view having many sons as social security. The program ended with her electoral defeat in 1977. ∎

Traders jostle in a line outside a bank, waiting to get small change for their businesses. Calcutta, West Bengal.

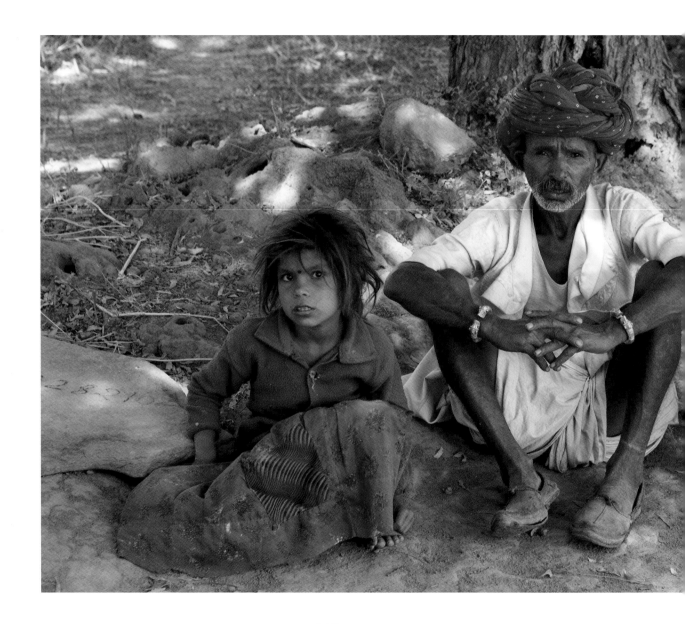

POVERTY

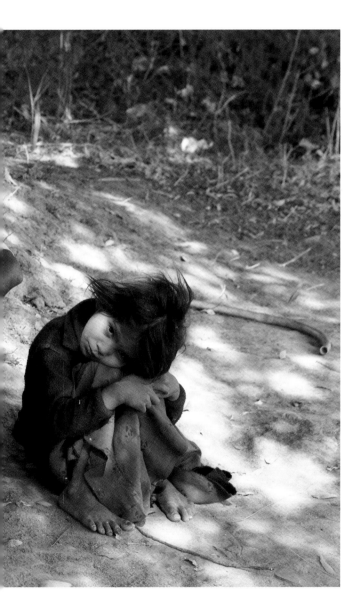

40 percent of the world's poor and 30 percent of the world's malnourished come from India. In the subcontinent, three-quarters of the population live on less than two dollars a day, one third on less than one dollar a day, and one quarter on less than 30 cents a day. Nevertheless, India is still on course to send a spacecraft to the moon.

Substantial improvement of these figures would involve the destruction of the caste system (which restricts hundreds of millions from education, employment, and ownership), a revision of the Hindu karma of acceptance, female emancipation, and a massive investment in infrastructure and irrigation.

Employing 60 percent of the nation, the Indian agriculture industry does not help matters, since Indian farmers vote to prevent reallocation of land to more profitable industries not subject to often treacherous weather patterns.

While it is estimated that one third of India's middle class has come from poverty level in the past ten years, the eradication of Indian poverty can only be viewed as a long-term hope. ■

A farmworker with children. Shahpura, Rajasthan.

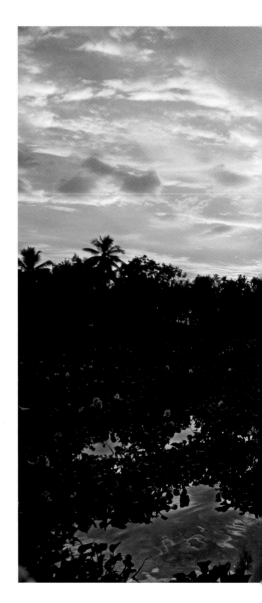

A villager punts his canoe with a wooden quant in the shallow backwaters, where it is the traditional form of transport. Kumarakom, Kerala.

142

Q

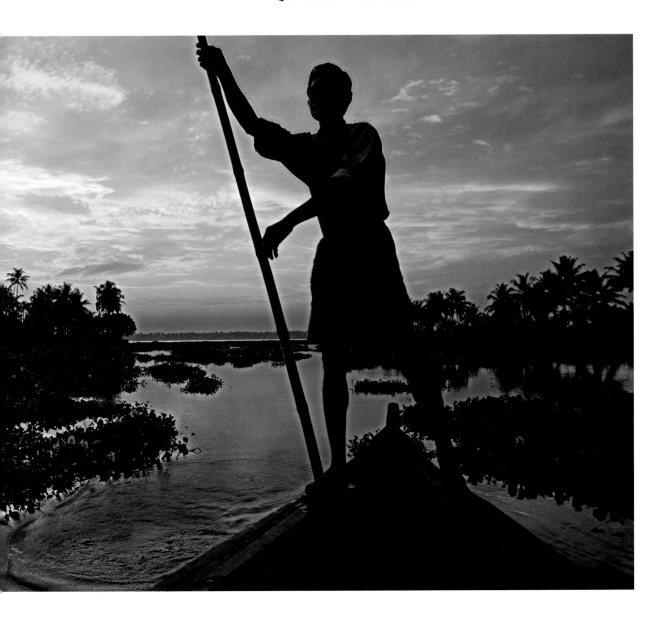

A train passenger cools a foot out the open window during the slow climb through the Aravalli Hills from Khambli Ghat to Phulad Junction, Rajasthan.

RAILWAYS

With seven different classes of carriage and accommodation, the Indian Railways of past years could always guarantee an eclectic mix of fellow passengers, as revealed by Section 77-A of the Indian Railway Act, which limits the railways' liability for the transport of donkeys, sheep, goats, mules, camels, horses, and elephants.

A more realistic primer to Indian Railways could be found in their Archives of Feedback. There Pooja Jaithalia describes how a popcorn vendor stole his purse with all his hard-earned money on the Bangalore–Jaipur Express; a naval lieutenant commander complains of an attendant making "vulgar passes" at his wife while she was traveling alone; and Armando D'Souza writes despairingly, "To the Manager, Indian Railways. There in train no proper sanitation. No proper door are locked in toilet and not working properly the toilet flashing. So please do come forward to make better improvement in latest world humanity. Thanking you. Armando" (2006).

As you might gather, Indian rail travel was pure hell, from hours spent in a ticket line to such overcrowding onboard for the cheaper classes that passengers slept on luggage racks or stood for up to twelve hours—without air-conditioning, in temperatures reaching 113 degrees Fahrenheit. And let's forget the bathrooms.

By 2004, the railways were losing billions a year when a political clown named Lalu Prasad Yadav was made federal railway minister. Just cleared of a corruption charge, he was now charged with running the world's busiest rail system, with four billion passenger journeys a year. By abandoning restrictive carriage numbers, developing online booking, and installing air-conditioning in all classes of trains, he created an annual operating profit of 200 billion rupee ($4.5 billion) within two years.

As a result, he is one of the most in-demand management gurus, lecturing at the World Bank, Harvard, and MIT.

The Archive of Feedback is now dotted with Lalu fan mail. ■

R

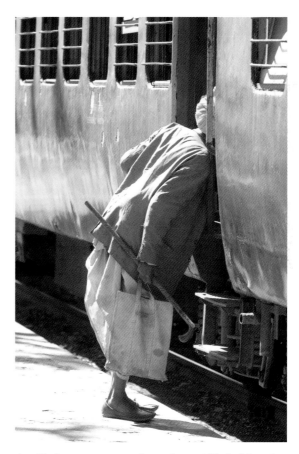

An elderly passenger searches railcars at Phulad Junction, Rajasthan, for the son who is due to meet him.

RAJ LEGACY

So pointedly polite are Indians in avoiding the subject that only once on our travels were we confronted with the matter of British rule. A teacher leading a school excursion caught my accent and began a hectoring history lesson, cataloging injustices of the Raj government; undoubtedly his rant would still be in full flow but for the fact he'd cornered me on a single-track bridge at Orchha and was holding up traffic in both directions, forcing him to scribble his e-mail address with the promise of further revelations.

The British Raj—officially known as the British Indian Empire—existed from 1858, when the rule of the British East India Company was transferred to Queen Victoria as the crown, until partition in 1947.

The devastation of World War II forced Britain to reduce its extended imperial holdings—which at one time covered a quarter of the world's land mass—planning a peaceful, staggered withdrawal from India by 1948. Instead, a mediatory meeting of Hindus and Muslims reached stalemate. Division was hastily agreed, the border line drawn through towns and communities where minorities fled, fearing what might happen to them after handover—Muslims to Pakistan, Hindus and Sikhs to India.

Over 14 million people were displaced, and in the ensuing panic, law and order broke down. Many died on the long marches to their new homelands; others, in rioting and fighting. The eventual toll reached half a million dead.

The British Raj left a legacy of a working but bureaucratic government and judiciary, improved education and irrigation, and a vast rail network, but far greater is the legacy of an unresolved caste system and a bungled partition resulting in wars and entrenched tensions between India and Pakistan. ∎

Unnoticed above a pink stucco shop in the marketplace at Karaikudi, Tamil Nadu, stands a statue of the Hindu goddess Gaja Lakshmi, flanked by two British soldiers holding what appeared to be whips, instead of the traditional bayoneted rifles.

"Yes, whips," said the guide. "You know, for whipping the workers." Then he stood patiently by the open car door as I stared at the tableau.

This darker side of British rule had been somehow forgotten in my Boys' Annual yarns of the Raj, yet here it was, in a nation that assiduously removes visual evidence of British rule (and being described to me in politer terms than the ones used by the teacher on the bridge).

RELIGION

Hinduism

India's 800 million Hindus believe in Brahmin (the true god that is found in all things and worshipped in the form of a thousand gods), in the law of karma (whereby every action has an effect, and everything has a cause), in reincarnation (wherein the soul lives on in another body, with a new life based on behavior in past lives), and in the lifelong ambition to break out of this cycle of reincarnation. While Hinduism can bring comfort, joy, salvation, and meaning to its believers, thus binding this most disparate of nations, it also keeps the lid on the poverty-stricken majority as they watch the privileged few flourish. ∎

Statues of the Hindu goddess Kali are prepared in a backstreet
workshop prior to a festival. Calcutta, West Bengal.

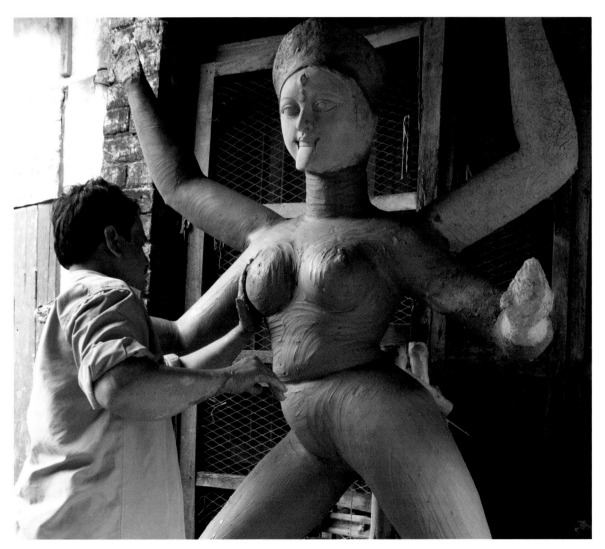

*An individual statue of Kali is molded from wet clay
for the festival. Calcutta, West Bengal.*

Jain Dharma (Jainism)

At dusk, the complex of Jain temples at Sonagir, Madhya Pradesh, can seem eerily deserted, which only increased the shock of being confronted by a man of around six-foot-two wearing spectacles and nothing else.

"This man," explained our guide, "is a Jain monk." Jainism, which originated in India, is one of the world's oldest religions. Its four million followers in India are well known for their literacy. Did we have any questions?, the guide wanted to know.

Alex, struggling to maintain eye contact, asked why his hair was tufted at the front. "Because the Jain monks have renounced all worldly goods," said the guide, "including scissors, of course, so he pulls his hair out by hand."

In an attempt to lighten the scene I asked if he pulled it out with the strain of maintaining his life-time celibacy, but the guide said that was no problem because, since the monks eat banana root, such thoughts do not enter their heads.

At a loss for words, we watched the monk smile, give a gentle wave of his peacock-feather fan, and walk off. ∎

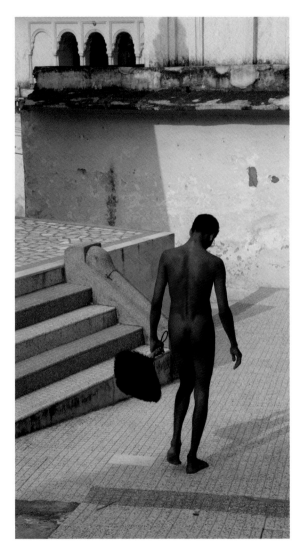

A Jain monk, Jain temples at Sonagir, Madhya Pradesh.

RELIGION

Islam

Although Islam is the second-largest religion in India, the nation's 140 million Muslims are poorly represented in the government, judiciary, army, and schools. Though political expediency and extreme nationalism keep religious differences on the boil, millions of Hindus and Muslims successfully share communities, villages, and towns. Inevitable flashpoints are widely reported by the media, which has long recognized peaceful coexistence as an enemy of circulation. ∎

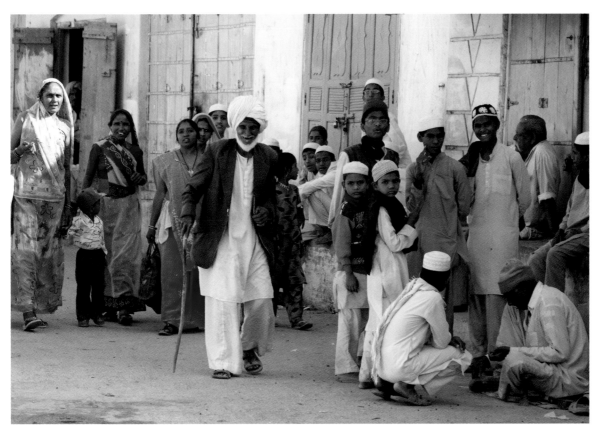

Muslim villagers react to the rare sight of a camera. Rann of Kutch, Gujarat.

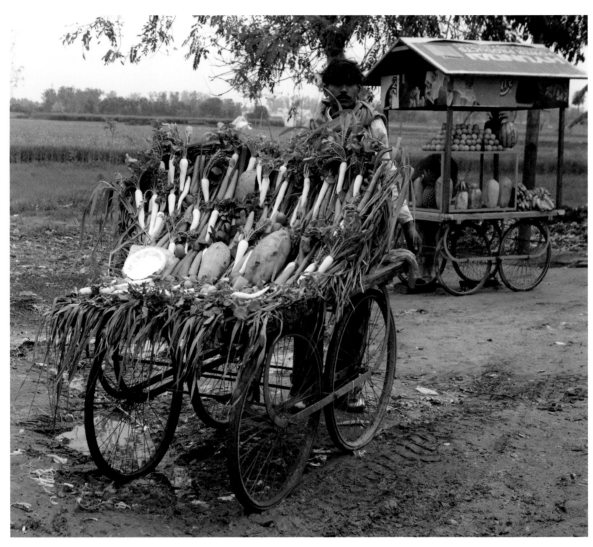

A vegetable seller has pulled out the stops with his limited stock, subtly hiding his rival's more minimal fruit display from the driver's line of sight. Rishikesh Road, Calcutta.

152

RETAIL DISPLAY

Lacking the luxury of climate-controlled shops or refrigeration, traders have developed high levels of skill in displaying their wares, particularly short-lived local fruit and vegetables. It is the roadside hawkers, though, given only a split second to persuade passing drivers to stop and buy, who have taken it to an art form. ∎

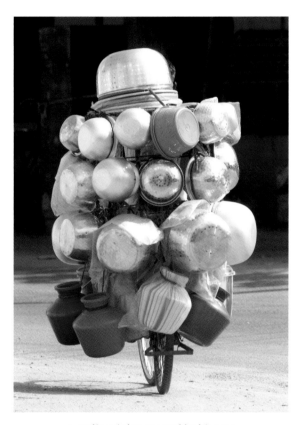

A cycling tinker encased by his pots. Tanjore, Tamil Nadu.

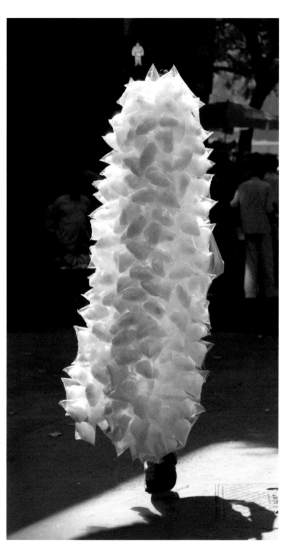

A Mumbai street trader is lost behind his high-impact display of cotton candy.

RICE BARGES

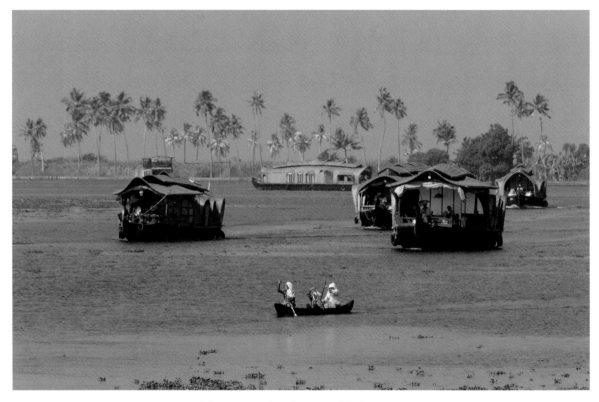

*Three women in a dugout paddle between
rice barges. Alleppey, Kerala.*

Leaving behind virtually no ecological footprint, rice barges cruising the Keralan backwaters offer responsible tourism that is hard to describe without using the oft-abused word *magical*.

Powered mainly by a single outboard, converted rice barges roam Kerala's five hundred miles of backwaters (a network of five lakes linked by canals, both natural and manmade, and fed by thirty-eight rivers) at a pace barely faster than a gondola, serving what many view as the best regional food.

Some barges take two passengers, some a dozen; some take four hours, some four days. It's viewing the real, rural India from a few feet without intrusion, begging, or hassle; it's traveling without car horns, customs, or constant tipping.

It's magical. ∎

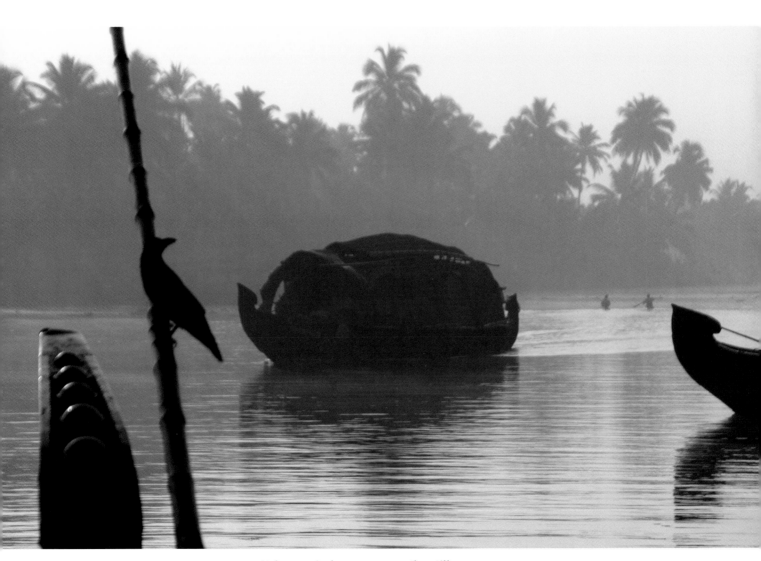

At dawn a rice barge passes another still
moored for the night. Alleppey, Kerala.

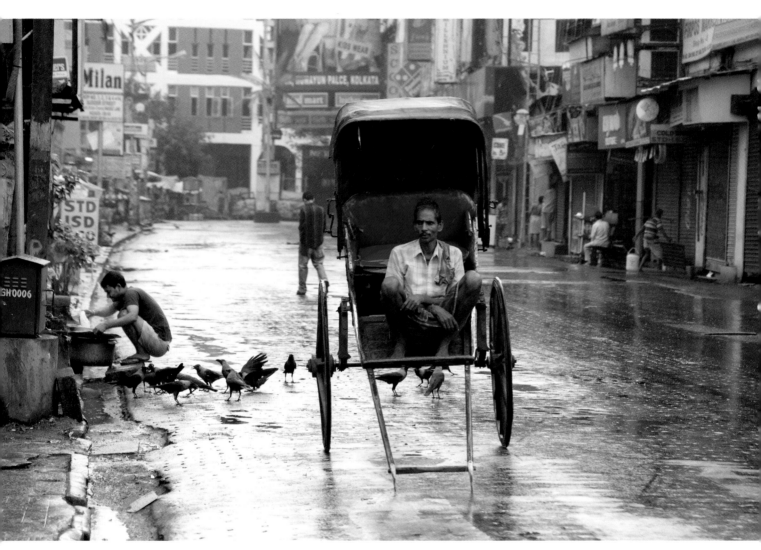

*A Calcutta puller sits on his rickshaw, impervious
to the rain, waiting for his first fare of the day.*

RICKSHAWS

And still they're there . . .

With the rest of the world abandoning the anachronistic rickshaw, Calcutta has become its last holdout, where rickshaws are pulled by a stick-thin army of migrants from dirt-poor neighboring Bihar.

The British tried to get rid of rickshaws in 1939 and withdrew licenses in 1945, with little effect. In 1972 rickshaws were banned from major highways, and in 1982 12,000 were seized and destroyed, but still to no effect. When the Communist government of West Bengal planned to outlaw them completely in 2005, with the chief minister describing them as "inhumane symbols of human bondage," the pullers went on strike, and the trade survived; in 2006 they were officially banned—with the promise of rehabilitating the pullers—but neither enforcement nor rehabilitation ever materialized.

With no new licenses being issued, illegal operators—who survive by bribing police—outnumber the legitimate, nearly all of them renting the rickshaws on a daily basis while sleeping in cheap hostels or on the street, living off their meager earnings. ■

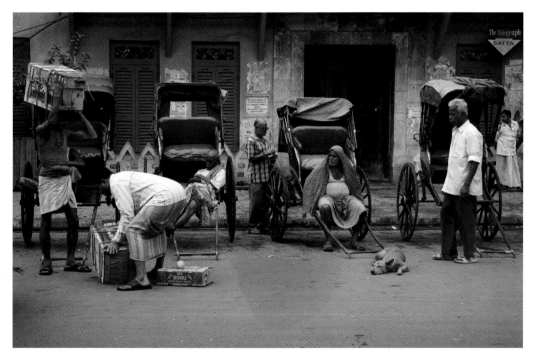

Quiet business on rickshaw rank.
Calcutta.

157

RISHIKESH

Straddling the Ganges as it leaves the Himalayas and spreads to the plains, Rishikesh has been holy to the Hindus for centuries, yet it took the Beatles' visit to Maharishi Mahesh Yogi's ashram in 1968 to thrust the city into the Western conscience.

While all but George left disillusioned, Rishikesh— a seething mix of temples, ashrams, yogic pitches, and hard-sell stalls that has long stifled any spiritual serenity—remains a magnet for tourists and pilgrims seeking enlightenment, meditation, and cheap drugs.

And don't expect eggs for breakfast—Rishikesh is strictly vegan. ■

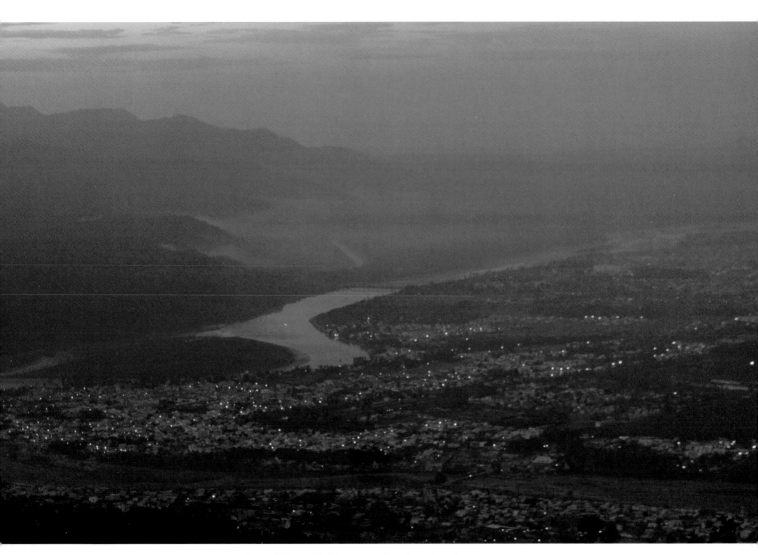

*Street lights still shine as a misty dawn breaks
over the Ganges. Rishikesh, Uttarakhand.*

SADHUS

S*adhus* are holy men who renounce all worldly goods, comforts, and sex in a lifelong bid to find enlightenment and gain *moksha* (liberation from the eternal circle of reincarnation) through meditation, ascetic yoga, and prayers. Once initiated, *sadhus* are legally dead—an advantage to those who are escaping from unacceptable family or financial problems. While becoming a sadhu officially frees initiates from the caste system, hierarchal sects within the *sadhus* still determine their standing.

There may be five million *sadhus* in India. Some live in ashrams, temples, forests, or caves, while others spend their lives roaming the subcontinent on foot or via free rail travel; all survive on donations and goodwill. (Some embark on extreme feats of endurance to speed their attainment of *moksha*, though entry in the *Guinness Book of World Records* is no guaranteed fast track.)

If the *sadhus'* privations seem extreme, it must be remembered that most spend many of their waking hours high on cannabis or hash. India's liberal approach to soft drugs may stem from the public's reverence for, and the authorities' wish not to upset, these representatives of God.

Whether, at the end of the day, they feel they've reached enlightenment may not seem a big deal after years on drugs—though for any nonsmoker it can be a tough road. ∎

(*Note*: The *sadhu* is not to be confused with the Indian guru: viewed more as teachers or mentors, gurus can come from any walk of life, and they are always at hand to offer advice on any conceivable subject.)

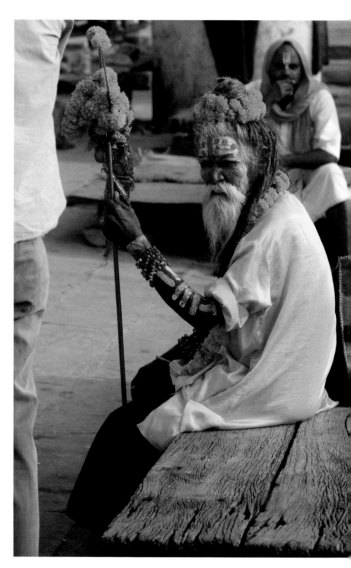

A sadhu *rests on a ghat. Varanasi, Uttar Pradesh.*

SAFETY STANDARDS

The daily sight of Indians risking life and limb might shock those first arriving from the cosseted, litigious Western world. But the combination of unemployment, poverty, and a belief in karma that leads people to accept whatever the fates bestow contributes to a sense of the cheapness of life that makes a mockery of what health and safety standards do exist. ■

The six barefoot men painting a Mumbai hotel, balancing precariously on the rope-tied bamboo scaffolding, share one safety helmet and four safety harnesses between them— luxuries that have more to do with the hotel's insurance policy than the workers' welfare. Mumbai. ▶

SARIS

Behind a slick silk mill and showroom in Varanasi are overcrowded slums packed with Muslim piece-workers who work at home. Here our guide stopped beside a squatting man feverishly hammering on a metal punch in a darkened room.

"It's hard to see, as the power gets cut four hours a day," our guide explained to us, "but this man is making the jacquard cards that program the looms."

As our eyes adapted to the semidarkness, we could see that he was reading a roll of graph paper with twelve holes to the inch, covered in a floral sari pattern. By his toes, overlaying a cardboard jacquard card, was a perforated metal stencil, 480 holes wide, ten holes deep.

"He's reading the colored squares of the graph and punching matching holes in the jacquard, a different line of holes for each color," said the guide. Kneeling low, I saw that the man's gaze never left the graph paper, and realized that he was touch-punching faster that I could touch-type after fifty years' practice.

The guide moved on and then came back for me, asking if everything was okay. When I said I couldn't believe what I was seeing, he just smiled and revealed that this man, being skilled, got a few rupees more than the others. ∎

Varanasi, Uttar Pradesh.

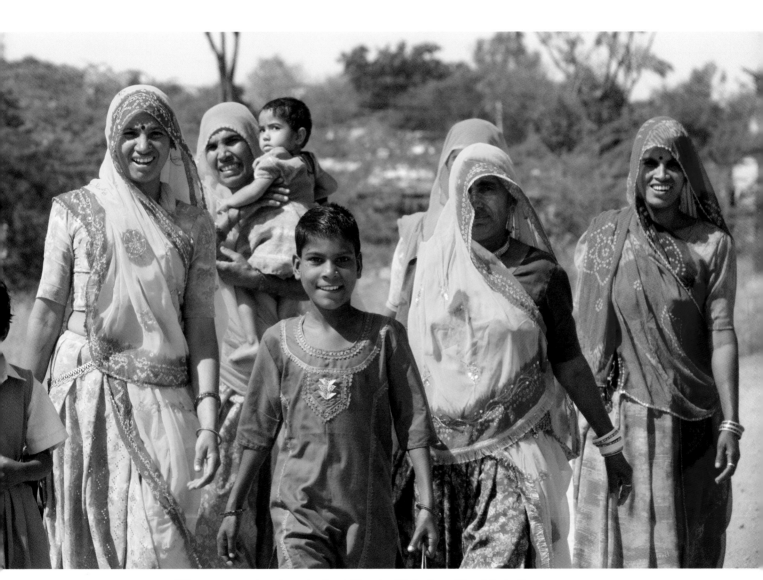

Village women return home in the vivid saris of Rajasthan. Nimaj, Rajasthan.

SEX DISCRIMINATION

Women

The Indian government's 2008 announcement of plans to pay poor families in seven states nearly $3,000 each toward raising daughters highlighted the illegal practice of female fetus abortion, but drew criticism from activists who claimed the problem of sex-selective infanticide comes mostly from those above the poverty line; in the wealthy state of Punjab, for example, only 793 girls are born for every 1,000 boys.

Traditionally, a female baby will not only incur dowry commitments but also grow up to face limited income and few rights to property and inheritance; as a result, ten million female fetuses have been aborted nationwide in the past twenty years.

Should the female fetus be spared, she faces discrimination from all quarters—education, employment, domestic treatment, marriage, and pregnancy (natural childbirth problems are exacerbated by the fact that 90 percent of women are malnourished, and half give birth without trained help).

Every hour, Indian women face two kidnappings, two rapes, four molestations, and seven incidents of family cruelty, but even these figures (National Crime Records Bureau, 2006) barely represent reality, since they are based only on reported incidents.

In widowhood, women's misery continues, with many of the 40 million Hindu widows cut off from their previous lives, shunned by their communities, and forced to beg or live off charity.

While the government's $3,000 might encourage families to raise more Indian girls, it will do nothing to change the traditional treatment of those girls, an abhorrence that will only be cured by education and gradual social change. ∎

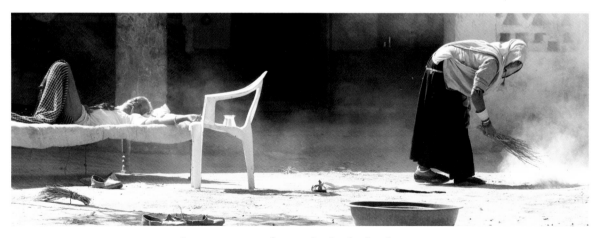

A woman sweeps a farmyard as her husbands rests.
Nimaj, Rajasthan.

Under fading Bollywood posters, a group of
hirjas *play cards. Mysore, Karnataka.*

Hirjas

Hirjas (or *hijras*), also known in India as the third sex, are usually male eunuchs (though occasionally transsexuals or hermaphrodites) who dress as women and prefer the term *Aruvani*.

After crude castration, *hirjas* are no longer viewed as male or female. Though they do not fit into any existing legal framework, they are now moving into politics to assert some measure of clout. When one became mayor of Katni, a long court battle ensued, ending with a 2003 judgment that forced the *hirja* from the office (which was reserved for a woman) on the basis that she was still technically a man.

In the state of Tamil Nadu alone, there are an estimated 150,000 *hirjas*, drawn to the region's annual Aruvani Festival. This joyous knees-up celebration bears little relation to the rest of the year, when *hirjas* are marginalized by society and forced into prostitution and begging.

Though *hirjas* are traditionally welcomed to sing and dance at weddings and festivals in the belief that they bring good luck, growing abuse has created an aggressive streak in them, which does little to advance peaceable coexistence. ∎

SMILING

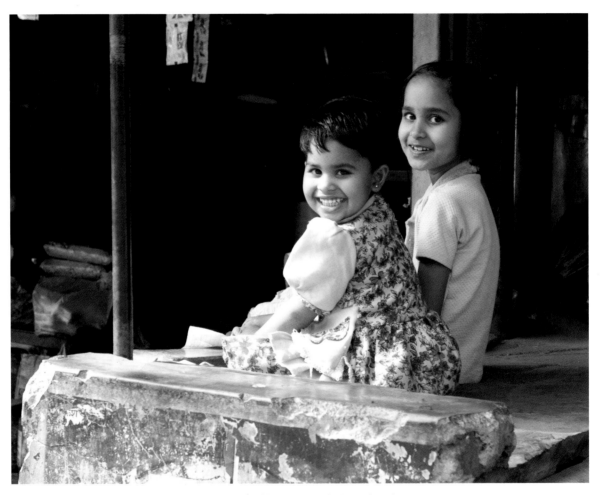

Two smiling children wait as their mother shops.
Near Devigarh, Rajasthan.

It was not the scenery, nor the wildlife, nor the colors, nor the anarchistic madness that made us fall for the country, but the number of Indians who, with little to their name, still smile in greeting. ■

SNAKE CHARMERS

For much of the twentieth century, snake charmers were a staple entertainment at weddings, festivals, and anywhere two or more tourists gathered. Supposedly hypnotizing the lethal snake with a musical instrument, snake charmers usually played safe either by removing the venom glands or fangs, or by sitting out of range. Naturally the snakes—invariably cobras or vipers—would eventually get the hang of the act and not feel inclined to attack.

In rural areas some snake charmers were regarded as healers or magicians, called upon for a range of services from curing the common cold to raising the dead.

Now, with the threat of a seven-year prison sentence for owning a serpent under the 1972 Wildlife Protection Act, coupled with TV nature programs demystifying snakes, the profession's estimated million practitioners are in a steep decline. ■

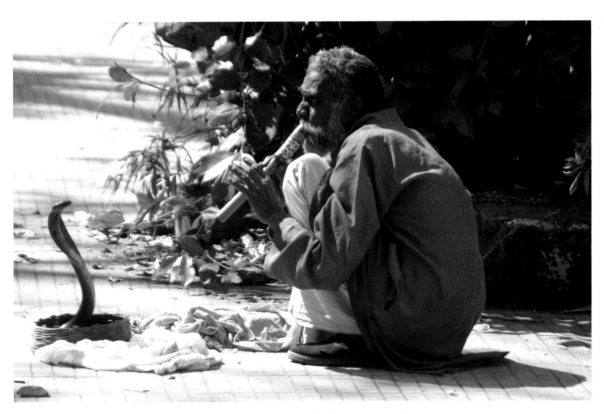

A snake charmer struggles for business. Mumbai.

STREET CHILDREN

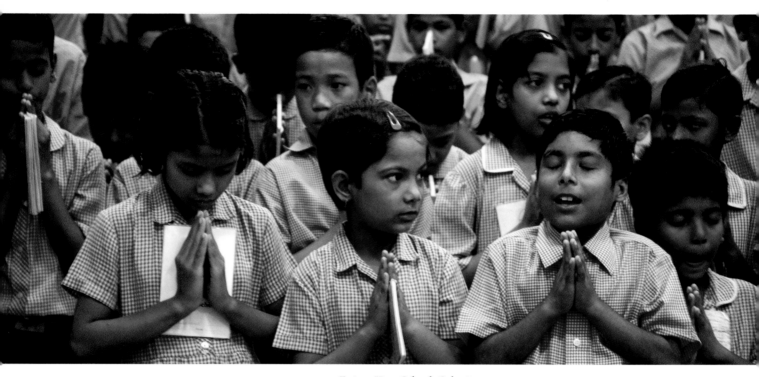

Future Hope School, Calcutta.

Immaculate in checked gingham, 150 boys and girls say morning prayers in a Calcutta School before an eight-year-old boy leads them on a squeeze harmonium in Abba's, "I Have a Dream." With eyes welling up in tears, it's hard to focus.

This is Future Hope School, founded twenty years ago by Briton Tim Grandage to save as many of the City of Joy's tens of thousands of street children as his energy and donations would allow. Working as an HSBC banker at the time, it was a newspaper photograph of a street boy being suckled by a mongrel that led Grandage to change his career and begin his work in Calcutta. The struggle began, and soon locals' resistance to foreign interference was quelled by the school's early successes. Alumni since have gone on to middle management positions and continued study at universities; others play for Indian Rugby XV (a passion of Grandage's since his days at Rugby School). Perhaps the greatest turnaround success story was Howrah Station's most successful pickpocket graduating to become Chief Security Officer of an Indian airline. ∎

Despite a full-day's administration (and signing for a $60,000 flat that will become an all-girl's college extension for thirty four pupils), Tim Grandage does a night's trawl around the railway stations for possible rescues.

It's not instant salvation; these bedraggled bundles have a natural distrust of adults, who have abused them in the past or plan to do so in the future, and it may take weeks of contact to build up enough rapport to persuade them to join the school.

On a footbridge Grandage nudges a rolled blanket and the face of an eight- or nine-year-old appears; he pulls away a cloth mask from the boy's face and tells me to smell the choking fumes.

"Glue," he says. "Four rupees a tube. Half of them are on it. I reckon if I don't get this one to the School in the next six weeks, he'll be dead."

The boy refuses to speak, grabs the mask to his face and covers himself again in the filthy blanket.

Grandage shrugs. "I'll be back tomorrow night and try again," he says. ▼

Railway station. Calcutta.

TAJ MAHAL

For one *New York Times* correspondent, the Taj Mahal presents an image "serene and perfect enough to tattoo inside an eyelid," but whether it has the same effect on you depends on your preconceptions.

Built by the Mogul emperor Shah Jahan (plus 20,000 laborers who took twenty-two years to finally complete the structure in 1653), the Taj Mahal is a mausoleum in memory of Jahan's favorite wife, Mumtaz Mahal. She died at thirty-nine in childbirth while delivering his fourteenth child.

The Taj Mahal was looted with the arrival of the British—the first governor-general even planned to dismantle it and sell the marble. Saved by Lord Curzon, who restored the building and accompanying gardens, the Taj was then swarmed by picnickers who chiseled off its surviving semiprecious stones.

Today this Muslim mausoleum is viewed ambiguously by a nation controlled by Hindu nationalists, who remember how the invading Muslim Moguls brutalized Indian people and Indian monuments. The past thirty years have seen growing pollution damage to the structure until the Supreme Court came down on local industries with restrictions or threats of closure, while formulating restoration plans.

Magical in its history, miraculous in its construction, and remarkable in its survival, the Taj Mahal captivates two million visitors annually. ∎

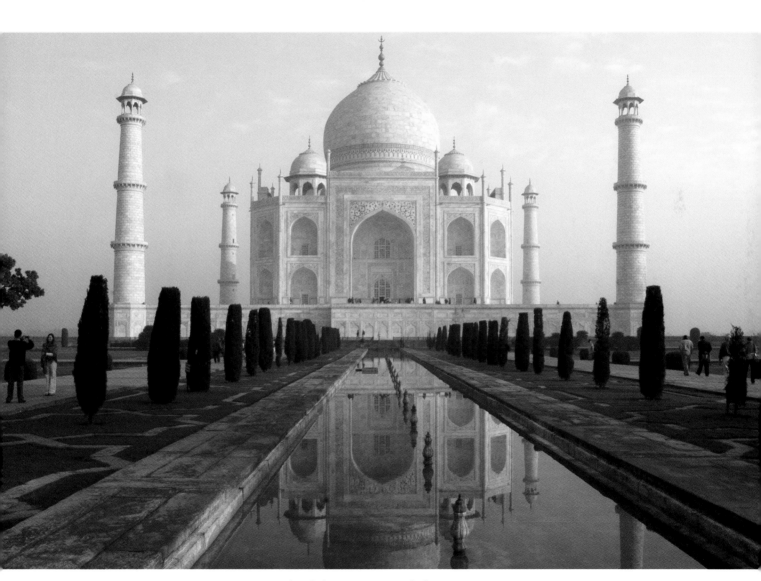

Taj Mahal, Agra, Uttar Pradesh.

TEA

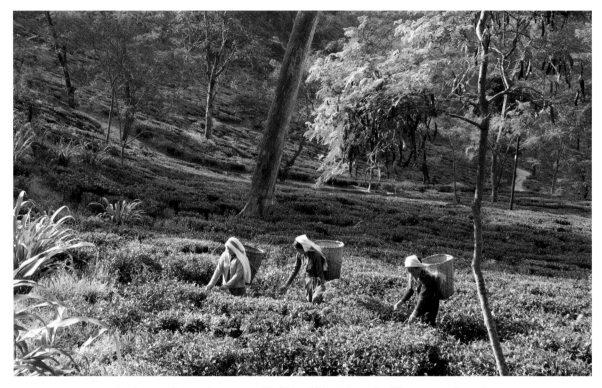

*Early-morning workers, part of India's picking army of millions, move through
a plantation picking only two leaves and one bud at a time. These tea leaves will be dried,
curled, fermented, and baked ready for packing. Glenburn, West Bengal.*

In 1833 the British-run East India Company lost its monopoly on the tea trade with China and, unwilling to believe the tea plant was indigenous to East Bengal, hastily imported 80,000 Chinese tea seeds to India. The Chinese variety struggled in Assam's heat, while the indigenous tea plant responded so well to cultivation that its planting spread throughout northeast India.

The world's largest consumer of tea, India and its $1.5 billion tea industry export new varieties to suit changing tastes. Assam and Nilgiri produce strong, dark tea, while Darjeeling, often called the "Champagne of Teas," is lighter and more delicately scented. Roadside chai, on the other hand, is a spiced black tea mix with optional milk and sweetener; its taste is best described as acquired. ∎

TELEPHONES

With three new cell phone subscribers every second, India has become the fastest-growing mobile phone market in the world, with 246 million subscribers in February 2008. A projected 40 percent of the population is expected to go cellular by 2010. The rising popularity of mobile phones contrasts to the sluggish growth of landlines, long regarded as a status symbol; traditional telephones stagnated at around 40 million in 2007.

Such is the size of the cell phone market that operators flourish, despite charging only 2 cents per minute for a call (including long distance within India). Investors see such potential for this market that in 2007 Vodafone paid $11 billion for 67 percent of the Indian Hutch network. Cell phones are rightly lauded as one of India's great economic successes, welcomed by all except professional letter writers, whose livelihood they threaten. ■

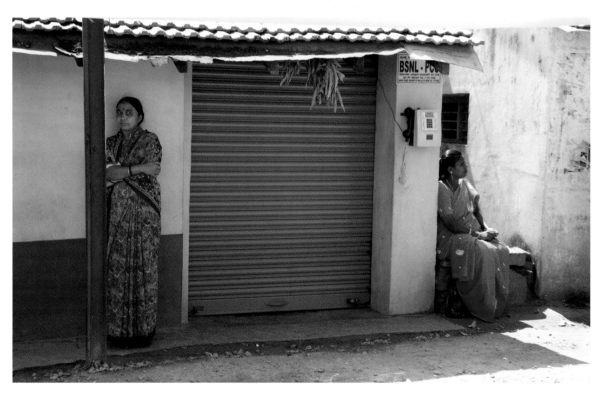

Two villagers await incoming calls on a landline telephone.
Outside Ramanagarm, Mysore, Karnataka.

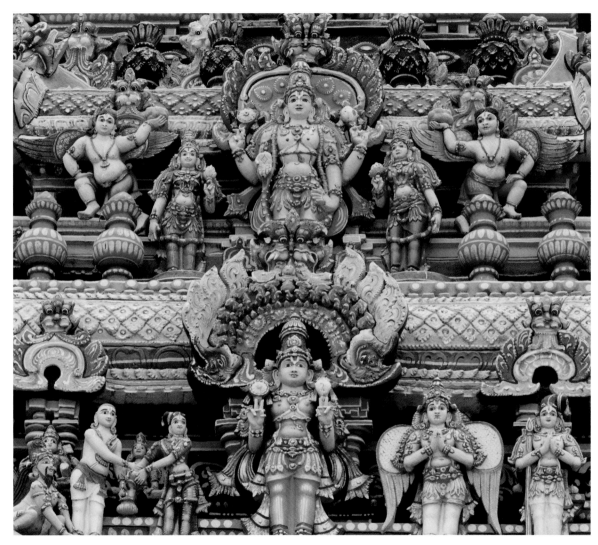

Detail of decoration on a temple.
Trichy, Tamil Nadu.

174

TEMPLES

The sheer scale of Indian temples is such that there are times when visitors, experiencing yet another barefoot shuffle as echoing guides bombard them with facts and figures, suffer a common condition known as "templed-out."

This is supposed to be a vacation, for heaven's sake.

But for every brochure temple steeped in whatever, there are a thousand more accessible examples, fulfilling their role in providing spiritual comfort, guidance, and hope to any Hindu, and probably leaving the visitor with a more lasting, realistic impression. ∎

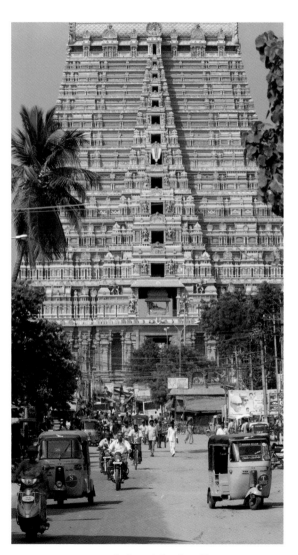

A priest prepares his roadside temple to bless the car keys of a passing driver. Near Athankudi, Tamil Nadu.

A temple dwarfs local traffic. Trichy, Tamil Nadu.

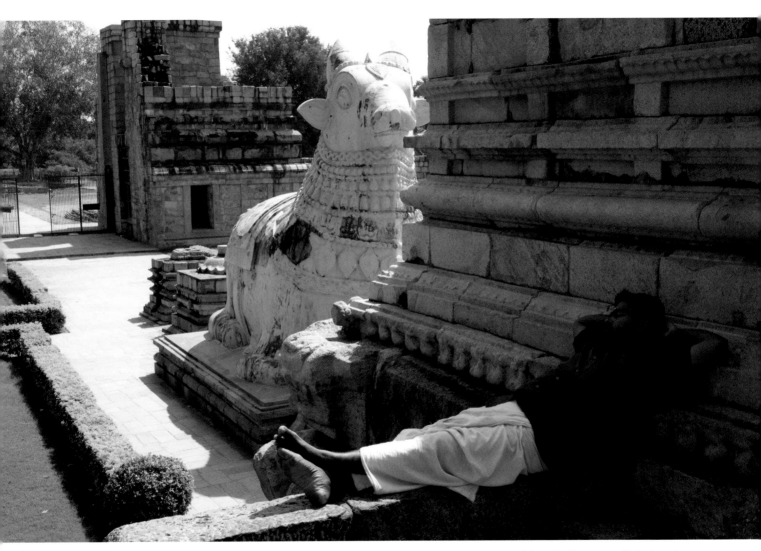

A lamplighter concentrates before the first tourist coach of the morning, knowing he'll be asked how to spell the location.
Brihadisvara Temple Complex, Gangaikondacholapuram, Tamil Nadu.

A gilded dome amid intricate temple carvings typical of Tamil Nadu.
Madurai, Tamil Nadu.

Brihadiswara Temple.
Tanjore, Tamil Nadu.

Erotic Carvings

In 1838, on the advice of his guides, British Army engineer Captain T. S. Burt made a detour through jungle to the village of Khajuraho, where he was confronted by a group of Hindu and Jain sandstone temples dating from around AD 950 to 1050, not only in amazing condition but featuring highly erotic friezes.

While in awe of the temples, he viewed the sculptures as "extremely indecent and offensive" (at this time, Victorian Britons covered piano legs for the sake of propriety). Visitors today often do not share Captain Burt's original impression, coming instead to gawk at the exotic couplings, athletic positions, and depicted pleasures that, in any other setting, might be viewed as pornography.

With the decline of the Chandela Rajput dynasty that built the complex, it became overrun by jungle, which probably saved it from the invading Moguls, while Khajuraho's remote location spared it erosion by industrial pollution.

There is no agreed-upon explanation why the erotica—representing 10 percent of the temple complex's total sculptures—was created, but it does resolve the debate of when pornography can be recognized as art.

The answer: After 950 years.　■

A view of the temples much as Captain Burt might have seen them in 1838. Khajuraho, Madhya Pradesh.

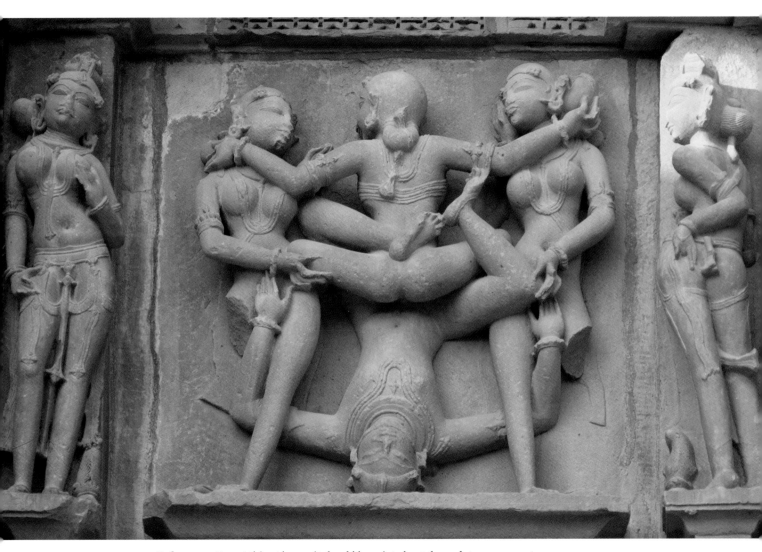

Before you attempt this at home, it should be pointed out the sculpture represents an aerial perspective of participants lying on the floor. Khajuraho, Madhya Pradesh.

TEXTILES

Industry

The Indian textile industry's target of $50 billion in exports by 2010 sits uneasily with the subsistence wages paid to many of the 35 million workers the industry employs. Minimum daily wage is often flouted in the struggle to meet demanding quotas. ∎

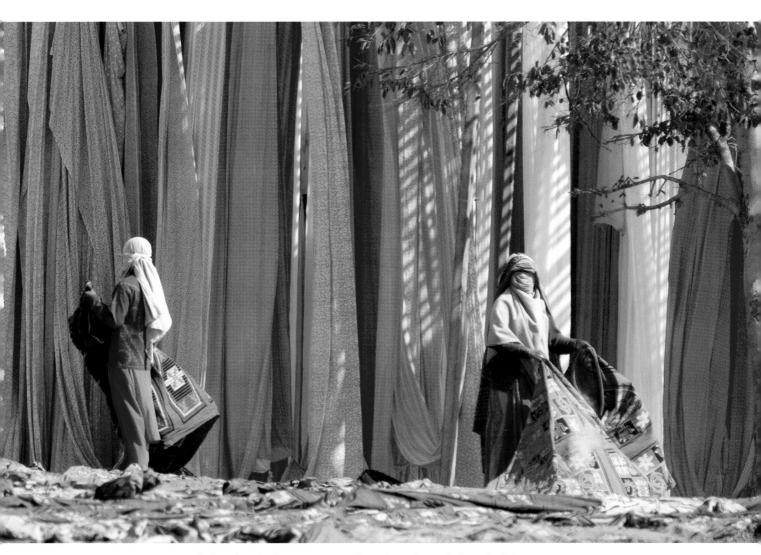

*Masked against the dust, women textile workers air rugs before a backdrop
of freshly dyed cotton drying in the sun. Jaipur, Rajasthan.*

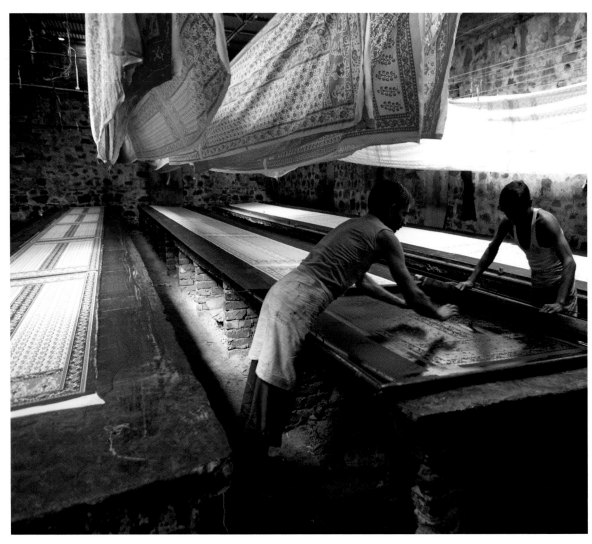

Two workers screen-printing fabric.
Jaipur, Rajasthan.

182

Silk

The process of creating silk starts with a caterpillar eating 50,000 times its birth weight in mulberry leaves. The caterpillar then nods its head 300,000 times in a figure-eight motion as it secretes liquid silk to form an enveloping cocoon. This silken cocoon produces up to a mile of silk filament, providing the raw material that powers the Indian silk industry (around 18 percent of the world's output).

Mahatma Gandhi, objecting on religious grounds to the need to kill the caterpillar within the cocoon, encouraged the alternative cotton-spinning machine. But it was an uphill struggle, given India's—and the world's—love of silk. ∎

A worker sifts cocoons in a giant silkworm market.
Ramanagara, Karnataka.

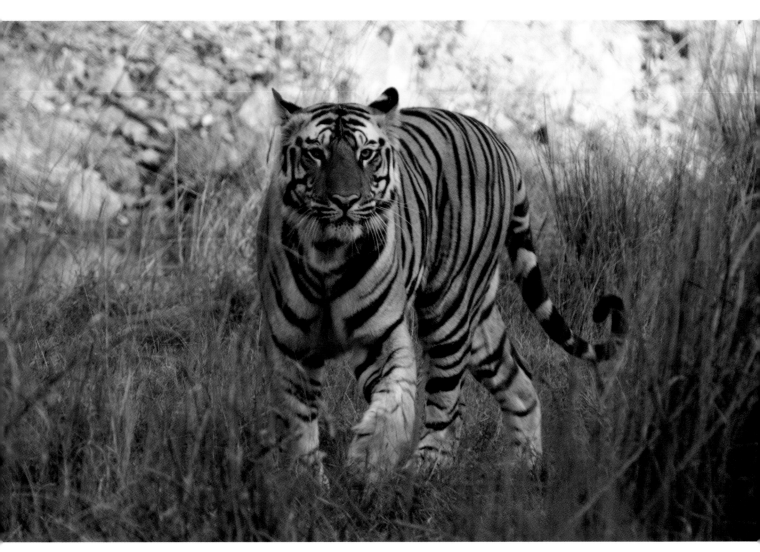

The male tiger catches the
deer scent and turns . . .

TIGERS

There's a tiger at a zoo near you. Alternatively, you can spend a month's salary flying to an Indian game reserve to be tossed around for days in a four-by-four on the off chance of spotting a wild one the poachers have missed.

Promised head counts bear little relation to the truth (which would cost the livelihoods of hundreds of locals reliant upon tourists), so a sighting should be viewed as an unexpected plus to a vacation and not brochure-guaranteed, as thousands of disappointed tourists attest each year.

Two hours into our first game drive in the Bandhavgarh Reserve, Madhya Pradesh, with just a wild boar and a dozing buzzard in the bag, we'd stopped the engine so I could photograph a spotted deer when the guide pulled my shirt and pointed down a path. "Tiger," he whispered. A young male was padding toward our open Jeep on dinner-plate paws—not a moth-eaten zoo version, this was a pristine and breathtaking specimen.

The guide's reassurances that we were safe fell on deaf ears—when that killer has you in his path, the mind makes a panicked and lightning-quick inventory of defense options (my best being to stuff my 600mm zoom down the tiger's throat as it leapt).

And then, on final approach, it picked up the scent of the deer and began stalking through the long, dry grass, suddenly switching into overdrive and obligingly leaping six feet over a stream during its vain chase. Such displays are so rare these days, the hardened warden asked for a print to hang on his wall, saying, "It just doesn't get better than that."

Well, to be honest, it did. As the defeated tiger ambled into thick scrub, other guides were called up. Within minutes eighteen Jeeps surrounded us, packed with tourists craning for a glimpse.

For two weeks we'd scoured other reserves without a sniff, fixing our smiles as passing tourists gushingly revealed how many tigers they'd seen and how close they were. Now it was our turn as strangers pressed for details; we slightly undersold the sighting and the number of shots taken, with a degree of schadenfreude rarely seen outside a tiger reserve. Then we drove off with a cheery wave, one of the less attractive breeds in Bandhavgarh that day. ∎

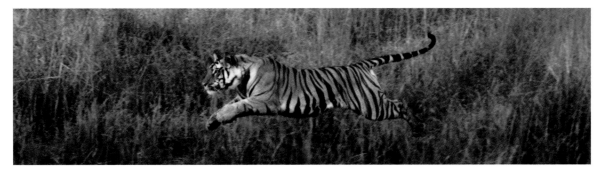

. . . and breaks into pursuit, following the deer across a stream before abandoning the chase. Bandhavgarh Reserve, Madya Pradesh.

TOURISM

Statistically, every tourist benefits thirty-four Indians (or thirty-five if you include the statistician), with India's nearly 5 million visitors spending 9 billion dollars annually. The Indian tourist industry is growing at a rate of 13 percent a year, leaving one to imagine just what the figures might be if they ever fixed the garbage and hygiene problems.

The Golden Triangle tour of Delhi/Agra/Jaipur is a must-see for many, but its popularity brings the downside of tourism, too—hassle, overcrowding, and begging are common problems. Yet tourists who spend the night in Rajasthan's former palaces bring in the revenue to save most from undeserved ruin. ∎

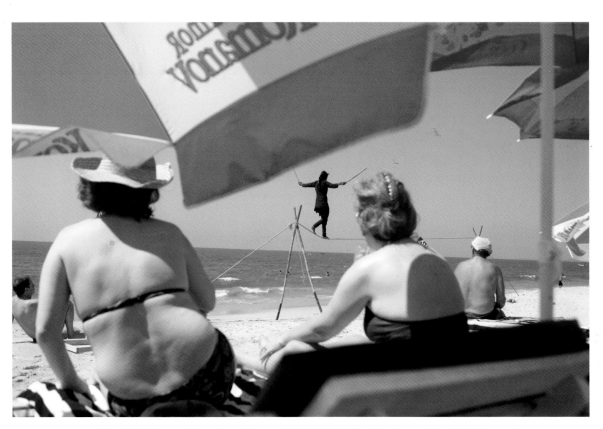

Beach holidays are booming, with most of India's 4,350 miles of coast free of tightrope walkers, sari sellers, and umbrella cocktails—but not here in Benaulim, Goa.

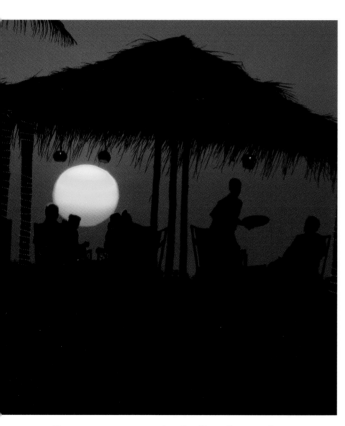

*Resort guests are served cocktails as they watch
the cabaret of sunset. Benaulim, Goa.*

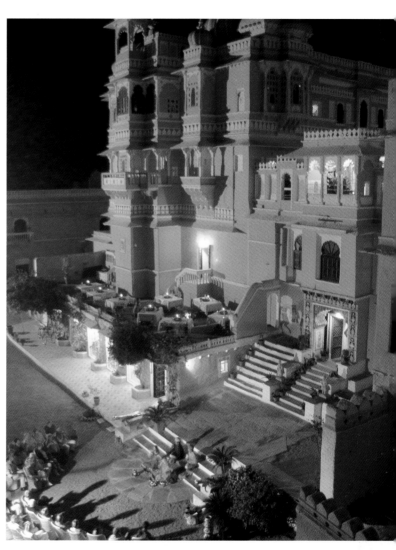

*Guests watch a traditional dance group at the floodlit
Deogarh Mahal Palace. Deogarh, Rajasthan.*

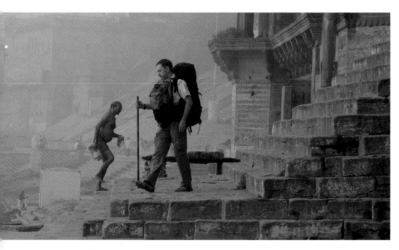

A back- and front-packer descends a ghat *to the Ganges, passing a pilgrim who is traveling lighter. Varanasi, Uttar Pradesh.*

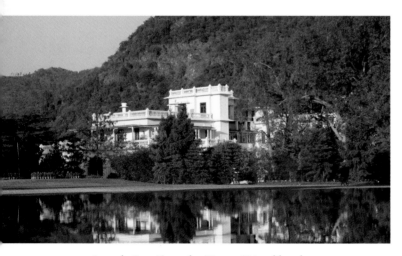

Ananda Spa, Narendra Nagar, Uttarakhand.

For the backpacker, India is a shoo-in for value, with transport, accommodation, and food so cheap as to be embarrassing. (*Safe* cuisine, however, may cost a little more.)

Health tourism has taken off big-time, offering yogic disciplines, ayurvedic traditional Hindu medicine, and holistic treatments that view the body and mind as a whole, the success of each approach often in the mind of the client.

In the line of duty I went for an ayurvedic massage with a dodgy outfit operating from a former hospital in Kerala.

After a cursory medical exam, they chose "a blend of aromatic oils to match your aura and remove individual blood toxins." They obviously viewed me as a weathered antique, since their concoction for me smelled like a foul mix of furniture polish and WD-40; the odor lingered for weeks.

For reasons unknown, the two-man massage team decided to coat me in the mix in the standing position instead of waiting until I was prone on the teak massage table, thus forcing them to take an end each, like fishermen wrestling a giant cod, till one of them had the bright idea of lifting me by the loincloth they'd fashioned from discarded surgical bandage—luckily the oiled knot slipped before full castration.

The massage proved "energizing and slimming," as promised—they'd had a great workout, and my wallet was 600 rupees thinner.

In retrospect, I should have sold the house and gone for the top-end Ananda Spa, where therapy includes crystals "energized in the moonlit foothills overnight and soaked in Himalayan rose distillate" and "rose quartz or amethyst wands packed with energy which they carry down their shafts." ∎

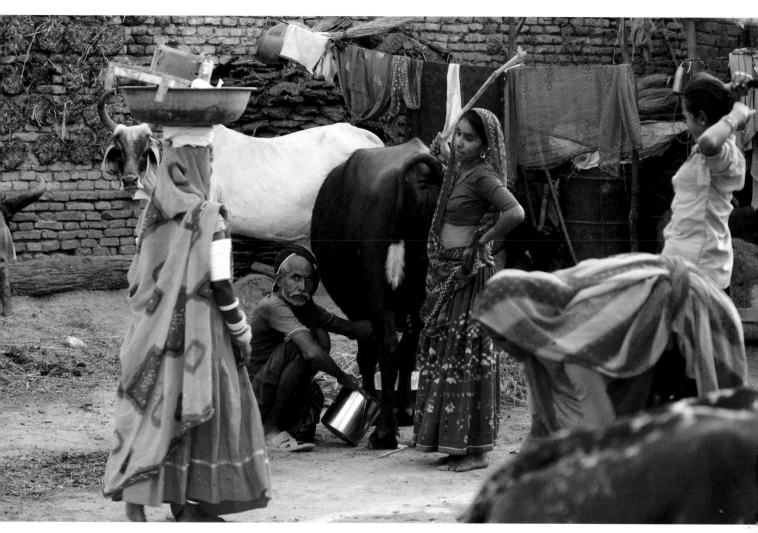

It could be said that rural tourism is the only way to see the real India, with a serendipity factor unmatched by the well-trodden tourist routes, throwing up experiences, sights, and surprises that linger longer in the mind than most forts, palaces, and temples. Ambala, Gujarat.

Mumbai.

Gridlocked in Mumbai's lunch-hour traffic, there is little to do but switch off the engine, while driver and passenger both try to nap and forget about Mumbai having over a thousand vehicles per mile of road. India's vehicle count, currently at 40 million, is expected to reach 200 million by 2030. ∎

TREE: NEEM

So many and varied are the beneficial properties of the neem tree that it is known as the Village Pharmacy. Its leaves, seeds, flowers, and bark contain liminoid compounds that are medicinally used as a sedative; for the treatment of diabetes, parasitic worms, chicken pox, head lice, skin diseases, infertility, viruses, and scabies; and in ayurvedic medicine. Neem oil is used in cosmetics, and neem gum as a bulking agent in diet foods. Young shoots of the neem tree are eaten as vegetables, while its flowers are used in pickles and soups, and its twigs for cleaning teeth. The neem tree is also a source of natural pesticide. Ecologically, it is invaluable as a weapon against desertification and as an absorber of carbon dioxide. All of that might explain why this one has had a house built around it. ■

Neem tree, Delwara, Rajasthan.

191

TURBANS

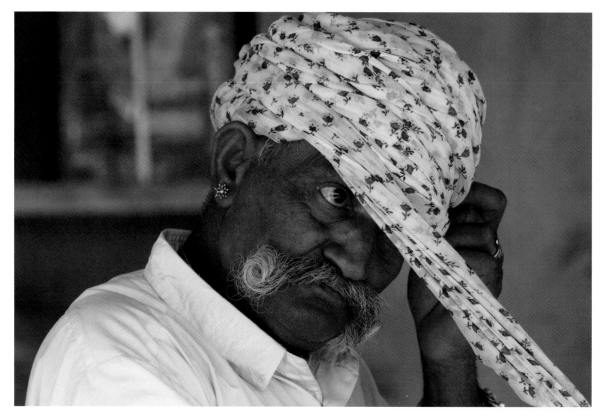

A Rajasthan shepherd winds his thirty-foot cotton turban into place. After two successive droughts in the 1960s, this man took his herd south in search of better grazing until turned back by authorities on the outskirts of Mumbai, returning to his village six months later with the herd intact, having walked over a thousand miles. Nimaj, Rajasthan.

Though a mere 10 percent of Indians wear turbans today, they are required headdress for most Sikhs. Turbans are ubiquitous in Rajasthan, where turban shape and color can indicate the wearer's social standing.

Valued for their temperature-moderating qualities (warming in cold, absorbent in heat), turbans are inevitably dwindling in the face of globalization. But they remain a glorious, charismatic display of color, style, and undiluted pizzazz. ∎

UNDERAGE LABOR

Although an accurate accounting is almost impossible, estimates of India's child labor population range from 60 to 115 million.

Some of these children have been abandoned by society, some provide vital income for impoverished families, some were forced into labor by amoral relatives; but it is bonded child labor that is the most invidious branch of India's money-lending tradition.

Human Rights Watch estimates that over 15 million such children are forced to work to pay off a debt incurred by struggling relatives or guardians granted small loans by unscrupulous creditors to pay for food, a dowry, or maybe a family illness. Given the outrageous interest rates and their desperately low wages, few of the children can pay off these debts in their lifetime. While some are released in favor of younger debt-tied replacements, many are forced to pass on the debt (in its original form or bloated by interest) to siblings, parents, or even their own children.

Even though this grotesque system was made illegal under the Bonded Labour System (Abolition) Act of 1976, it is tolerated by the government and by people who view it as a traditional practice among the poor that will take its own time to eradicate. Thus, it remains one of the most shameful aspects of what passes as Modern India. ■

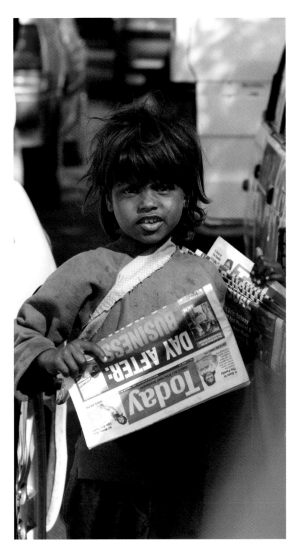

A child of unknown age "selling" giveaway newspapers to Delhi motorists.

VARANASI

V
In Hindu geography, the city of Varanasi is the center of the universe. Those who can wait patiently to die here, ensuring them the holiest of border crossings to the next world and thus guaranteeing escape from the cycle of rebirth and continued suffering. Second only to expiring in Varanasi is being cremated there, your ashes and sins washed away by the sacred Ganges.

Failing that, one million pilgrims come each year to bathe in the Ganges, and as tourism raises these ceremonies to must-see status, Varanasi struggles with a seething mass of cross-culture chaos, an uneasy mix of religious fervor and gawping cabaret. Though brochures might choose more exotic terminology, Varanasi's local industry centers on life, death, and tourism.

While such a situation survives because of Hindu tolerance, a liberal approach to privacy, and a need for tourist income, it is logistically unsustainable. ∎

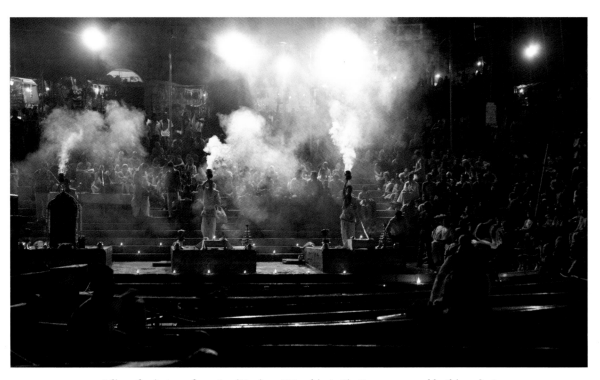

A line of priests perform Agni Pooja—"Worship to Fire"—on a sacred bathing ghat
on the Ganges, dedicating it to Lord Shiva. Varanasi, Uttar Pradesh.

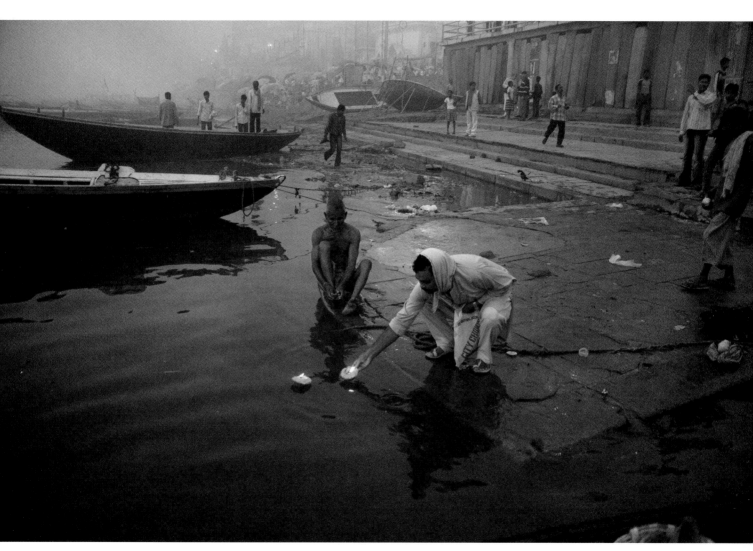

At dawn, a man lights a candle and floats it into the Ganges on a little raft of pressed leaf, edged by marigolds;
it may be in memory of a bereaved relative, or perhaps an offering to the sacred river. Varanasi, Uttar Pradesh.

VILLAGES

58 percent of Indian villagers have no electricity, 98 percent have no phone or television, 48 percent are illiterate, and 53 percent live on less than $1 a day, yet they represent 73 percent of the population.

While city dwellers might look upon them as romantic, most Indian villages are agrarian and subject to capricious weather and urban migration that keeps them at poverty level. ∎

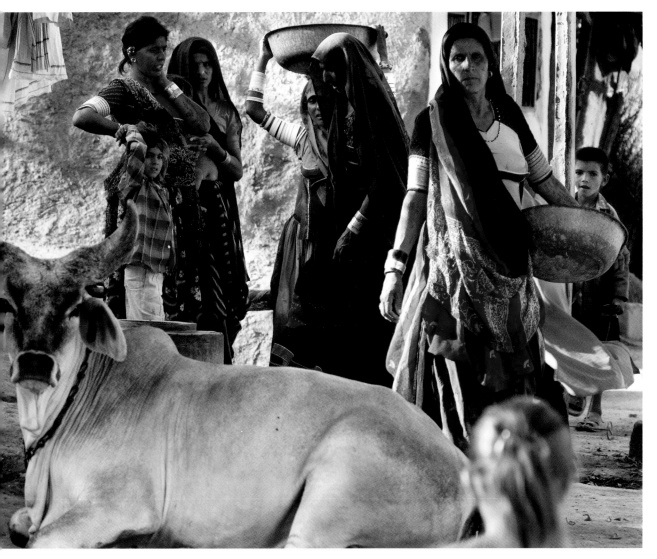

A village square. Little Rann of Kutch, Gujarat.

197

WATER

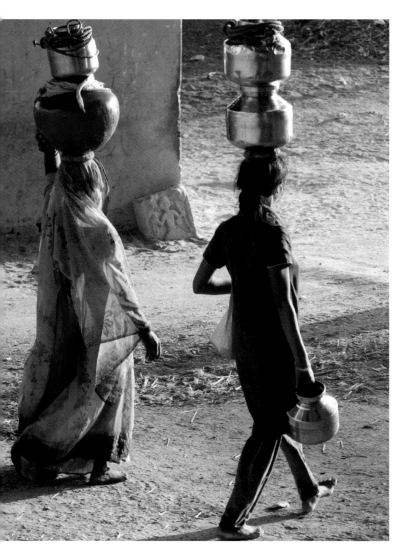

Women carry water back to their village.
Ambala, Gujarat.

For much of India, it's either too much water or too little—and not Western levels of inconvenience but flooding, drought, and subsequent starvation, at times costing thousands of lives.

While such disaster can be blamed on good or bad monsoons, the infrastructure to bring clean water to the masses is woeful (five years ago, research suggested that only a third of the nation's wastewater was being treated, with the remainder draining into the ground or rivers, and that contaminated water was claiming up to 700,000 lives a year).

In rural areas, 20 percent of Indians do not have access to treated water; in major cities the water supply lasts maybe four hours a day, while India's water table falls three to ten feet each year.

As ever, it's about money, bureaucracy, and the will to create a workable infrastructure. Don't expect a quick fix. ∎

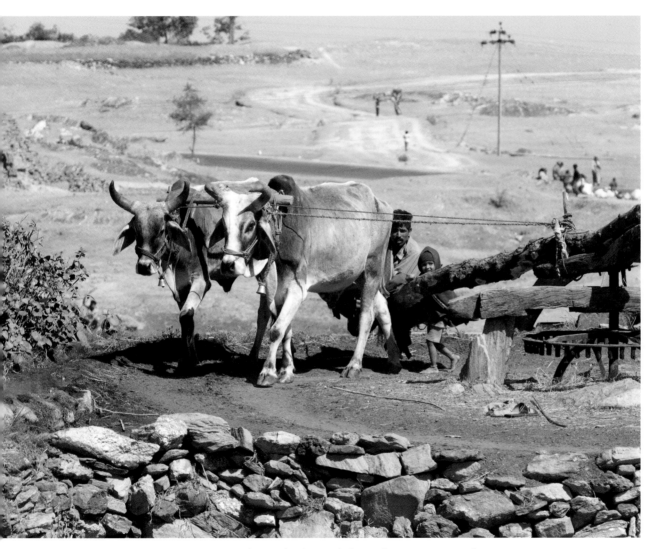

In a barren landscape, father and son operate a crude
ox-driven village well. Ranakpur, Rajasthan.

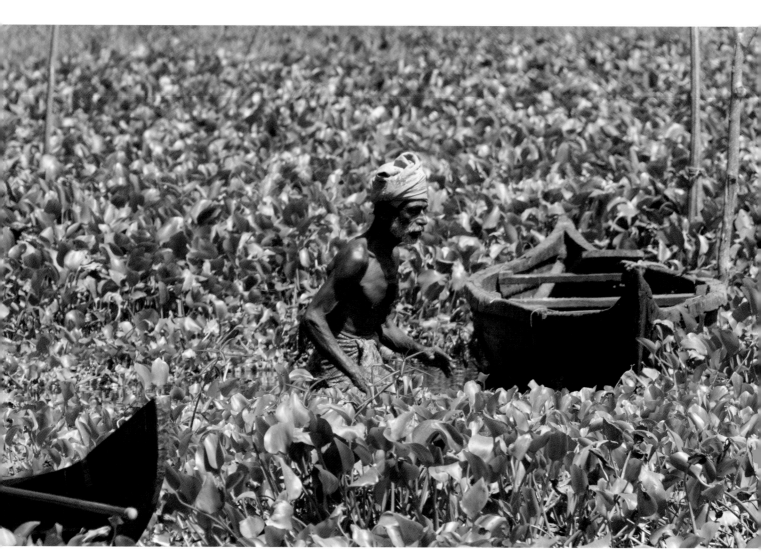

A fisherman struggles to his boat, which is locked in water hyacinth. Serenity Bay, Kerala.

WATER HYACINTH

The beauty of flowering water hyacinth on the Keralan backwaters masks its threat; as one of the fastest-growing plants on earth, it can double in area within two weeks, growing into six-foot-deep mats that choke inland waters. Water hyacinth affects transport and, by reducing light and oxygen, the fish population.

Chemical control raises unknown hazards; biological control (introducing known enemies such as weevils, fungi, and moths) is more benign but takes years to work; mechanical removal has proved too costly and manual removal too labor-intensive, as the plant weighs up to two hundred tons an acre.

As a result, vast islands of these plants, potentially invaluable as fertilizer, float past overcultivated fields fertilized with expensive chemicals or mud that is often gathered illicitly. ∎

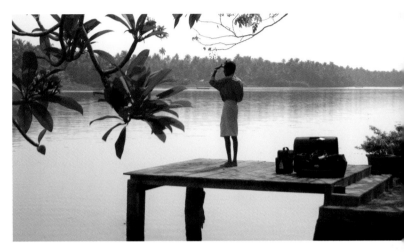

A porter awaits canoe transport for guests' luggage at Philipkutty's Farm. Kumarakom, Kerala.

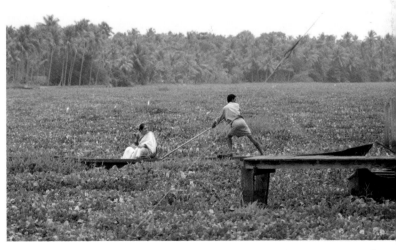

Two years later, the same jetty is choked with water hyacinth as a porter struggles to bring passengers ashore.

201

WEDDINGS

No one does weddings like India, but beneath the extraordinary trappings of color, ceremony, and general oom-pah-pah lies the evil, insidious practice of dowry payment, whereby the bride's family is expected to donate money, goods, or estate to the husband to counteract the future financial burden of the bride, who becomes part of the groom's family.

The anticipated burden of large dowries often leads to female abortions and infanticide, or forces families to invest less time, education, and resources in a daughter so that they can afford a dowry for her. Since the amount is set by verbal agreement, the groom's family can increase their demands in the days before the ceremony, even continuing indefinitely afterward.

When the bride's father cannot meet these demands, the bride may be subject to abuse; one woman commits suicide every four hours over dowry disputes, often to avoid punishments meted to those unable to meet dowry demands. The culture of "family honor" is so dominant, and the disgrace of a broken marriage so great, that her parents are unlikely to take her back, leaving the Indian bride no viable option of escape.

The inability to pay can also lead to the grotesque practice of bride burning by the groom or his parents; around 2,500 such cases were reported to police in the mid-1990s, and an untold number of brides have died in "kitchen fires."

Although the Dowry Prohibition Act of 1961 made dowry demands in wedding arrangements illegal, and Parliament classified dowry deaths as a domestic violence crime in 1986, this repellent practice continues. ∎

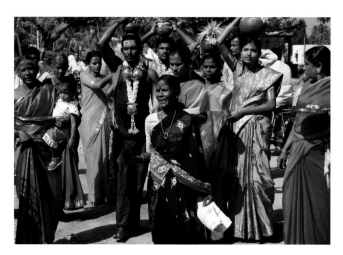

A village wedding procession.
Near Mysore, Karnataka.

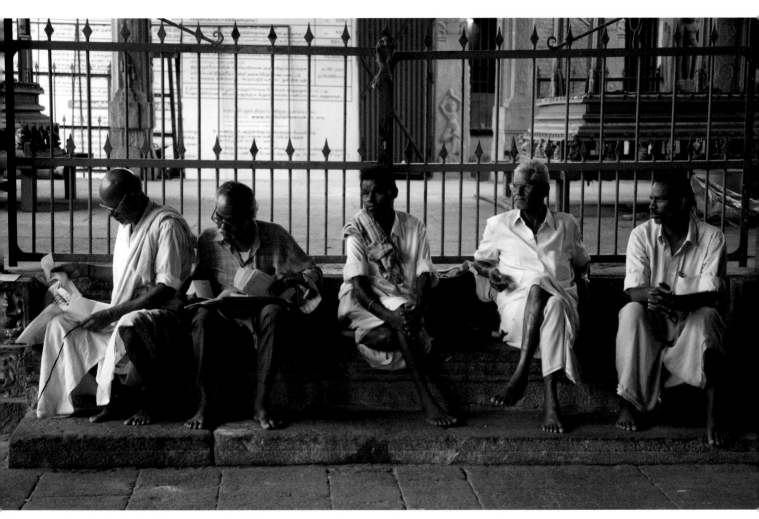

Professional matchmakers line up with their lists at the Meenakshi Temple complex; given details of would-be brides or grooms, they can, for a fee, check their list of available partners. If one is found suitable, the couple's résumés are then passed to astrologers, who will decide—for another fee—if the couple are compatible according to the planets. Meenakshi Temple Complex, Madurai.

Three sisters, brides-to-be, parade through their village. Near Deogarh, Rajasthan.

A prospective groom arrives on horseback at the bride-to-be's village house. Narlai, Rajasthan.

WESTERNIZATION

Paradoxically, the best reason for visiting India today is westernization, as it voraciously erodes the culture, crafts, and spirituality that make the nation unique.

After Independence, India nobly resisted Western influences by closing its markets to Western business and warding off foreign intrusion in its internal affairs until 1991; facing bankruptcy, India then accepted the inevitable by legislating reforms to wave in globalization and consumerism.

The question is whether India can, with both secular coexistence and spirituality, absorb the best of the West without losing its own culture. Indications are not good, with Mumbai's Café Paradise boasting Pepsi-flavored hookahs and Indians spending 200 million dollars a year on skin-lightening products that make them look less like healthy Westerners than sick Indians.

Historically, India has effortlessly absorbed every culture invasion, but this may be a culture too far, as the younger generation—one-third of Indians are under fifteen—are ruthlessly targeted by the West, and by a new god called Brands, as a ripe consumer market. ∎

Only a few years ago, riding pillion was empowering enough for an independent Indian girl; now, for many teenagers, it entails a reversed cap, cool shades, brand-name jeans, and an MP3 player. Bangalore, Karnataka.

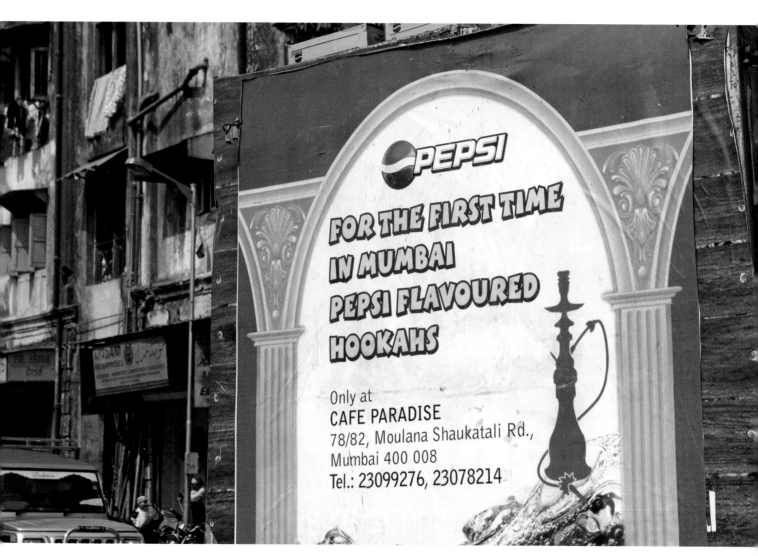

*Westernization comes to Mumbai as a Pepsi truck ad
tries to woo traditional hookah smokers. Mumbai.*

WILDLIFE

Like all Indian wildlife, this nilgai antelope (also known as blue bull), smugly eating its way through a field of mustard, is officially protected under the Wildlife Protection Act of 1972. This sweeping legislation satisfies Hindu culture but imposes a terrible burden on struggling Indian farmers, many of whom must spend nights in stilted huts guarding their crops and cattle.

(What the nilgai may not know is that it takes only a raised eyebrow, a knowing look, and the right price for just about any species to be produced from beneath a tarp in local markets.)

Meanwhile, as India struggles to satisfy both religious sensibilities and the needs of the strained farming sector, emboldened wildlife flourishes, and tourists have a field day. ∎

Near Nimaj, Rajasthan.

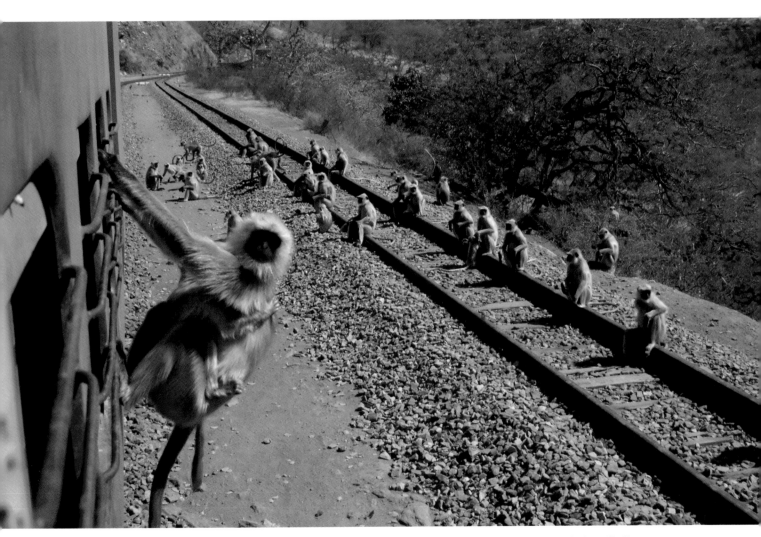

When the monkey population reaches unbearable levels in urban areas, some authorities order cosmetic relocation operations, but rural monkeys have free rein.

As a train departs, one mother with her baby still clings, hoping for one last piece of chapati from passengers. *Goram Ghat station, Rajasthan.*

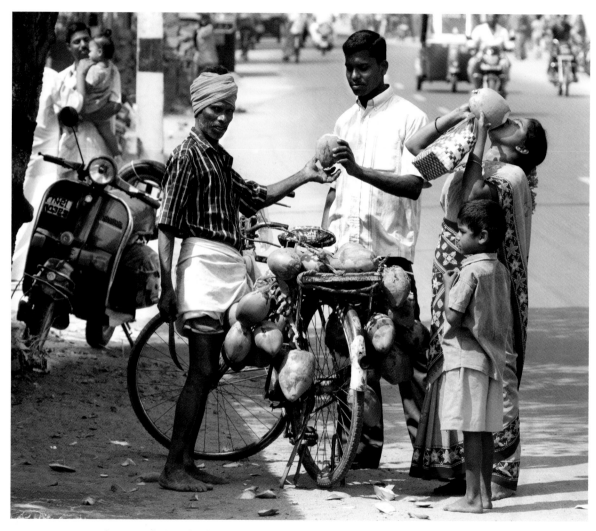

A xylocarp (a fruit with a hard woody pericarp—in this case, a coconut) is sold on the street by a vendor, who slices the top off with one swing of his machete so a family can drink the cooling coconut water within. Kanchipuram, Tamil Nadu.

YARN

A young worker weaving yarn in an industry that produces over 3 million tons a year—25 percent of the world's cotton yarn—and expects 50 billion dollars in exports by 2010, but offers its workers at this level of production dismal conditions and wages. ■

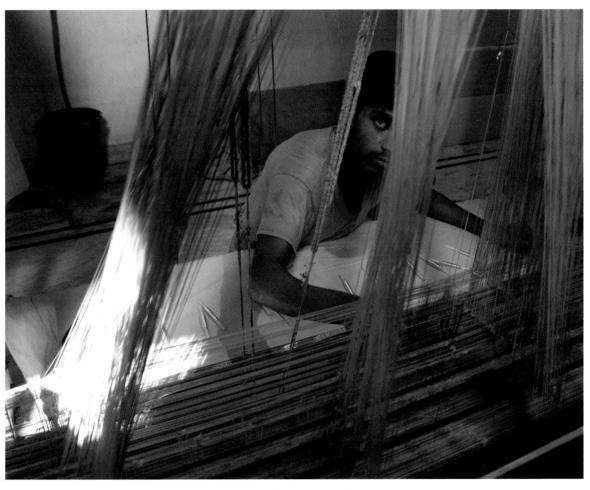

Varanasi, Uttar Pradesh.

YOGA

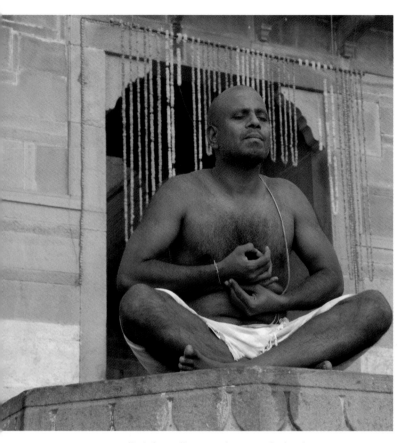

A yoga disciple meditates at dawn on the banks of the Ganges. Varanasi, Uttar Pradesh.

Yoga originated in India and is the oldest of physical disciplines. Combining stretching, breathing, postures, and meditation, yoga has been practiced by Hindus for thousands of years. But the times they are a-changin'.

Keeping yoga wrapped in cultural and religious mystique might attract those looking for metaphysical enlightenment but confuses would-be followers who lose out on its proven benefits. The Indian Army, recognizing the positive effects of yoga, recently incorporated yoga in their training program. Additionally an Indian parliamentary committee recommended obligatory yoga classes for children ages six to eighteen; despite opposition by Christian and Muslim interest groups on the grounds that yoga is a Hindu practice, the proposal is likely to be accepted.

Such mystique has no place in two burgeoning branches of the discipline more suited to the modern world: Yoga Lite, centered on breathing exercises and offering a quicker fix, and Hot Yoga, which involves exercises and poses during high-pressure sessions in rooms heated to over 100 degrees Fahrenheit with 50 percent humidity. These modern forms of yoga have helped push the discipline into a $3 billion-a-year business in the US.

It is the latter that is getting the swamis steamed up, bringing complaints from the Indian government as its creator, Calcutta-born but US-based Bikram Choudhury, tries to patent the twenty-six poses he copyrighted in 1978. The self-styled "Yogi to the Stars" plans to add to his 900 worldwide studios with a branch in Mumbai, and who can blame him? Think of those 200 million middle-class Indians stressed by chasing the fast rupee; think of all those rooms that won't even *need* heating. Just hold the metaphysical. ∎

Z

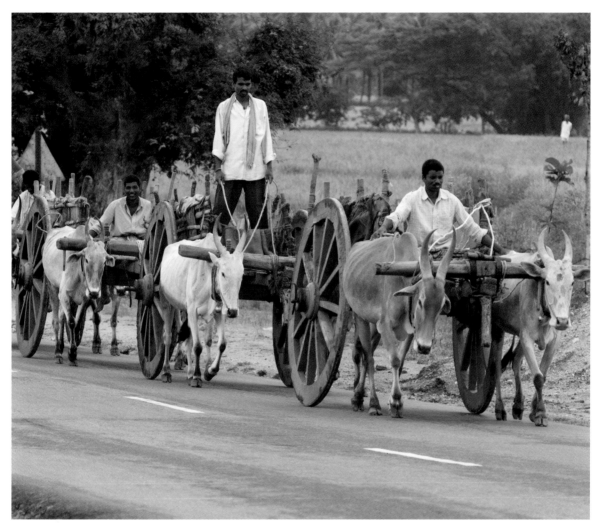

With a characteristic hump, pronounced dewlaps, and droopy ears, the zebu is a breed of cattle common in India.
Their forebears may well have been the first wild animal to disappear from the Indian wilderness,
when they interbred with domestic cattle during the Indus Valley civilization. Near Bannur, Karnataka.

INDEX OF PLACES

Acknowledgments

Though the dust jacket credits one name, this book is an accumulative team effort. Sincere thanks are due to Suzanne Lowry and John Lyth for my first journalistic breaks; to Dolores and Merril Halpern for their loyal friendship; to Bob Abrams for his belief in the project; to Erin Dress and Briana Green for their patient editing; to Mary Anne Denison-Pender of Mahout (UK) Ltd. for her meticulous itineraries; to Gautam Popat and all Banyan Tour Guides for their shared knowledge and care; to Alex for her love, support, and company all these years; to Zissou and Chlœ for making it all worthwhile; and to every Indian who treated us strangers as friends.

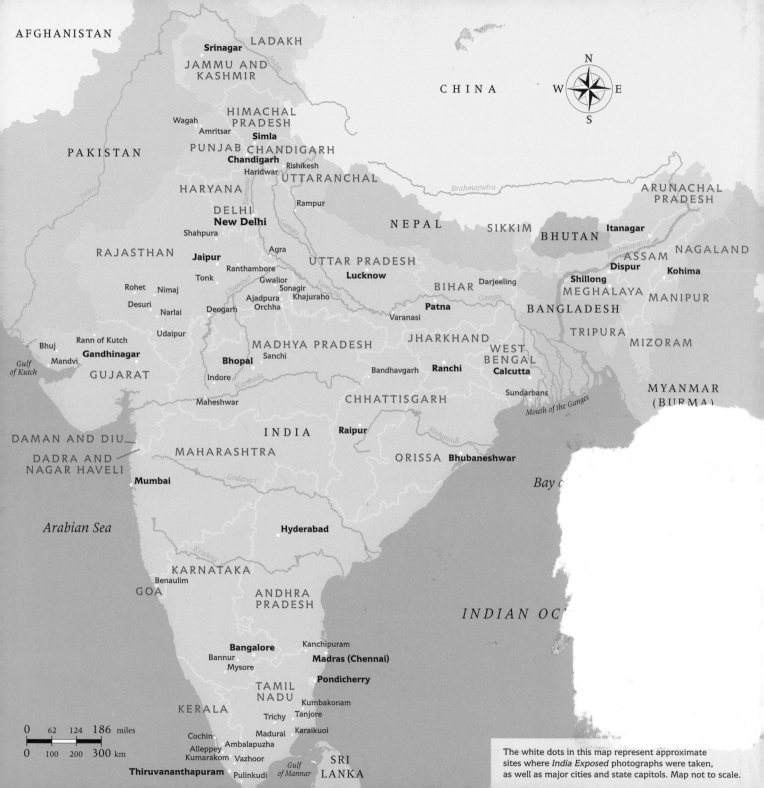

AFGHANISTAN

CHINA

LADAKH

Srinagar

JAMMU AND
KASHMIR

HIMACHAL
PRADESH

Wagah
Amritsar
Simla

PAKISTAN

PUNJAB CHANDIGARH
Chandigarh
Rishikesh
Haridwar
UTTARANCHAL

ARUNACHAL
PRADESH

HARYANA

Brahmaputra

Rampur

DELHI
New Delhi

NEPAL

SIKKIM

BHUTAN

Itanagar

ASSAM

NAGALAND

Shahpura

Ganges

Dispur

Kohima

RAJASTHAN

Jaipur

Agra

UTTAR PRADESH

Shillong

MEGHALAYA

MANIPUR

Ranthambore

Tonk

Lucknow

BIHAR

Darjeeling

Brahmaputra

Rohet

Nimaj

Gwalior
Sonagir
Khajuraho

BANGLADESH

Desuri

Narlai

Ajadpura
Orchha

Patna

Ganges

TRIPURA

MIZORAM

Deogarh

Varanasi

Udaipur

JHARKHAND

Bhuj

Rann of Kutch

Gandhinagar

MADHYA PRADESH

Sanchi

WEST
BENGAL

MYANMAR
(BURMA)

Mandvi

*Gulf
of Kutch*

GUJARAT

Bhopal

Bandhavgarh

Ranchi

Calcutta

Indore

Narmada

Sundarbans

Maheshwar

CHHATTISGARH

Mouth of the Ganges

DAMAN AND DIU

INDIA

Raipur

Mahanadi

DADRA AND
NAGAR HAVELI

MAHARASHTRA

ORISSA

Bhubaneshwar

Godavari

Mumbai

Bay of

Arabian Sea

Hyderabad

Krishna

KARNATAKA

Benaulim

ANDHRA
PRADESH

INDIAN OCEAN

GOA

Bangalore

Kanchipuram

Bannur

Madras (Chennai)

Mysore

Pondicherry

TAMIL
NADU

Kumbakonam

KERALA

Trichy

Tanjore

Cochin

Madurai

Karaikuoi

Alleppey

Ambalapuzha

Kumarakom

Vazhoor

SRI
LANKA

Thiruvananthapuram

Pulinkudi

*Gulf
of Mannar*

0 62 124 186 miles

0 100 200 300 km

The white dots in this map represent approximate
sites where *India Exposed* photographs were taken,
as well as major cities and state capitols. Map not to scale.